Río

Querencias Series

Miguel A. Gandert and
Enrique R. Lamadrid,
Series Editors

Querencia is a popular term in the Spanish-speaking world that is used to express a deeply rooted love of place and people. This series promotes a transnational, humanistic, and creative vision of the US-Mexico borderlands based on all aspects of expressive culture, both material and intangible.

Also available in the Querencias Series:

Coyota in the Kitchen: A Memoir of New and Old Mexico by Anita Rodríguez

Chasing Dichos through Chimayó by Don J. Usner

Enduring Acequias: Wisdom of the Land, Knowledge of the Water by Juan Estevan Arellano

Hotel Mariachi: Urban Space and Cultural Heritage in Los Angeles by Enrique R. Lamadrid and Catherine L. Kurland

Sagrado: A Photopoetics Across the Chicano Homeland by Spencer R. Herrera and Levi Romero

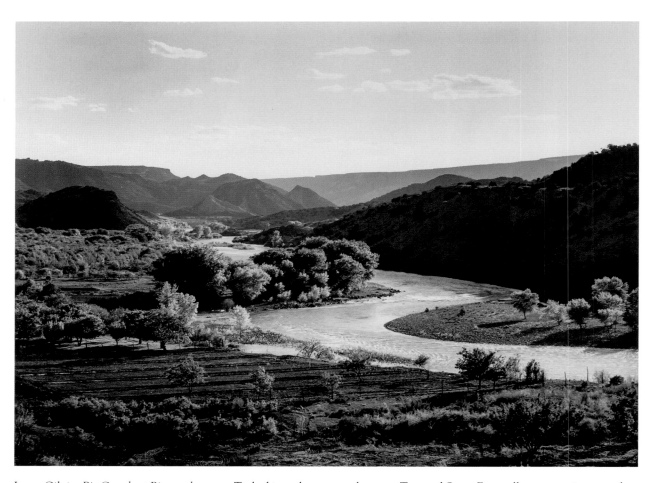

Laura Gilpin, *Rio Grande at Rinconada*, 1947. Tucked into the canyons between Taos and Santa Fe, small nuevomexicano settlements farmed chile peppers, beans, corn, and other crops using water diverted from the Río Grande in small canals, or acequias. Laura Gilpin, *Rio Grande at Rinconada*, 1947, gelatin silver print, P1979.134.151, Amon Carter Museum of American Art, Fort Worth, Texas.

Río

A Photographic Journey
down the Old Río Grande

EDITED BY Melissa Savage

INTRODUCTION BY William deBuys

UNIVERSITY OF NEW MEXICO PRESS ∫ ALBUQUERQUE

Library of Congress Cataloging-in-Publication Data
Names: Savage, Melissa, editor.
Title: Río : a photographic journey down the old Río Grande /
edited by Melissa Savage ; introduction by William deBuys.
Description: Albuquerque : University of New Mexico Press,
2016. | Series: Querencias Series
Identifiers: LCCN 2015039762 | ISBN 9780826356895 (pbk.
: alk. paper)
Subjects: LCSH: Rio Grande (Colo.-Mexico and Tex.—
Pictorial works. | Rio Grande (Colo.-Mexico and Tex.)—
Description and travel.
Classification: LCC F392.R5 R55 2016 | DDC 978.8—dc23
LC record available at http://lccn.loc.gov/2015039762

Cover photograph: Laura Gilpin, *The Rio Grande Nears
El Paso del Norte*, 1945, gelatin silver print, P1979.134.102,
Amon Carter Museum of American Art, Fort Worth, Texas.
Designed by Felicia Cedillos
Composed in Goudy Oldstyle Std 11.5/15.5
Display font is ITC Goudy Sans Std

*The New Mexico Humanities Council generously
provided funding to support publication of this book.*

*The Center for Regional Studies at the University of
New Mexico generously provided funding to support
publication of this book.*

For Jonathan

CONTENTS

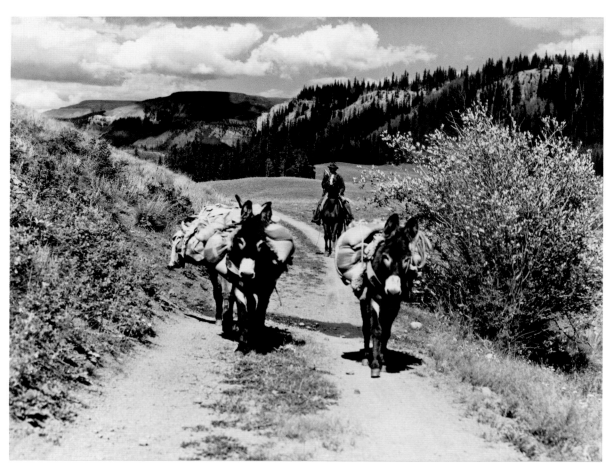

Laura Gilpin, *Sheep Camp Tender*, 1946. The Río Grande originates in the snowfields of the San Juan Mountains in south-western Colorado. Sheepherders tending flocks near the Continental Divide sent camp tenders carrying provisions on burros to the summer camps. Laura Gilpin, *Sheep Camp Tender*, 1946, gelatin silver print, P1979.134.216, Amon Carter Museum of American Art, Fort Worth, Texas.

PREFACE

Melissa Savage

We are who we are because of where we are.
—Lyle Balanqua, Hopi Tribe

The river is old. And for as long as it has run, the river has animated the
country around it. The Río Grande, alternately life giving and danger-
ous, tranquil and turbulent, has shaped the lives of the people who came
to settle by her side. And the river valley, in turn, is a landscape shaped
over centuries by those settlers. The photographic images in this collec-
tion tell the story of how the river was woven into each of the successive
cultures that inhabited the valley.

Ancestral Puebloan people were the first permanent settlers, migrating
to the valley from the west, then settlers filtering up from New Spain,
bringing Indo-Hispanic ways of life, followed by a wave of American cul-
ture. Sometimes settlers shared knowledge and customs. Sometimes there
were violent clashes between cultures. But the traditional lifeways of these
overlapping cultures gave gifts that are still part of everyday life in the
valley: artifacts of material life—woven rugs and blankets, pottery bowls,
silverwork, riatas, spurs—as well as relationships of respect for neighbors
and the earth and the sharing of resources, especially water. Each culture,
one after the other, laid patterns of custom and tradition that are still
embedded in the communities of the Río Grande Valley. And at the heart
of the valley, the river continues to eddy and flow, and to sustain the life
around her.

I first came to the Río Grande Valley as a young woman, to write a story

on early efforts to restore cottonwood tree groves along the riverbanks. In my old pickup, I drove south from Santa Fe on a two-lane road, before there was an interstate highway. I planned to interview ranchers and farmers about the ribbon of riverine trees shading their homes. They fed me chicken and biscuits and shared their stories with me. But standing in the dappled green light beneath the cottonwood canopy, on the banks of the muddy Río Grande, it was I who felt at home. I stayed. And over many decades of living near the river in the high desert of northern New Mexico, I have become who I am because of where I have been.

My interest in historical photographs of the Río Grande del Norte, the great river of the north, began with the beautiful photographs of Laura Gilpin. Her 1940s portrait of the river and its people—traders, trappers, farmers, gold miners, cowboys, rangers, and shepherds—captured a diverse and fading past. I then discovered the vast collection of Wilbur Dudley Smithers, who for decades photographed the Hispanic and cowboy cultures of the Texas border region. Every photograph is a glimpse into a life or place in the past. In the moments after one photo was taken, the raft of unsteady mules sets out into the swirling current of the river. Boaters slip around a bend in the stream and first set eyes on the big rapids. Gazing at these images, we are in a time machine, face to face with a flickering instant from the past.

Time and landscape intertwine deep into the past on the Río Grande. First there were only wild things. Springs bubbled up in the mountains, crystals on the crust of snow melting in the warmth of the sun to forge freshets streaming toward the river. The river coursed in braided channels across high alpine meadows. A sea of pines sloped down the mountains of the watershed to the valleys below. Into the dry, crackling country of the lower valley and the canyons of Big Bend, the river cut through geologic layers into the rock of deep time. Water withered in the southern sun and sank into sands, until only a remnant of freshwaters flowed through the marshes of the delta into the Gulf of Mexico.

And then, about a millennium ago, the first people created a society on the banks of the Río Grande, nurtured by the sweet water. Ancestral Pueblo people built compact villages near the river, and their hand was light on the valley. Old trade routes followed the river, carrying furs and turquoise south and parrot feathers, shells, and copper bells north. The soft midvalley filled with the fragrant smoke of piñon and juniper drifting from hearths in

Melissa
Savage

H. H. Chapman, *Pulling the Float "Binnacle Bat II," Rio Grande River, New Mexico,* 1918. Aldo Leopold is a storied name in New Mexico, where he began his long career in conservation. The mountain wilderness of the state shaped his early vision, but Leopold loved the Río Grande, on whose then abundant waters he camped and hunted waterfowl. Here, a young Leopold pulls a scow he built, the *Binnacle Bat II,* to the bank near Tomé, New Mexico. Courtesy of the Aldo Leopold Foundation, www.aldoleopold.org, AldoLeopold.leo0297.bib.

mud homes. The big river running through it shaped social structures, food systems, ceremony.

Centuries later, settlers from the Spanish and Náhuatl cultures to the south migrated upriver. They followed explorers, the first being the shipwrecked Cabeza de Vaca and his companions, around 1535. Military expeditions established a frontier culture on the fringe of the rich cities of the south. Indo-Hispanic villages created a complex system of irrigation ditches, or acequias, that watered orchard rows of peaches and apricots and meticulously tilled rows of corn and chiles.

Lastly came the Americans, known in the valley as Anglos. With the transfer from Mexico to the United States of all the territory north of the Río Grande, change began to accelerate: The rush for gold in the San Juan Mountains, the headwaters of the river. Great herds of cattle driven to railheads. Vast plantations of cotton, sugar, and citrus in the lower valley of the river in Texas. The growth of the cities of Brownsville, El Paso, and Albuquerque. And the start of the era of the great engineering feats that ultimately tamed the river.

As historian William deBuys points out in his introduction, the entry of photography into the region coincided with the beginning of the major transformation of the river to suit human needs. We see images of bridges, railroads, and major dams and irrigation structures on the river. But the images collected here also reflect patterns of life from a deeper time. Pueblo women washing grain in baskets. The tranquility of small settlements hidden in a cottonwood bosque on a river meander. A boy with his mule selling water from the river. A herd of sheep crossing a bridge on its way to summer grazing in the high country. Many photographs give us glimpses of old ways that still lie beneath the hustle of our technological society.

The book is divided into seven photographic bundles: Crossings, Trade, Cultivation, Flooding, *Los Insurrectos*, Big Bend, and River's End. Each bundle is introduced by an essayist. Introduction author deBuys has lived most of his life embedded in the village life of northern New Mexico. Essays by a Pueblo woman and a Hispanic farmer portray personal experiences of their cultures. Other essays reflect the perspectives of authors steeped in the history of the river and its valley. The diversity of voices in these essays embodies the enduring nature of the diverse cultures of the Río Grande Valley.

Melissa
Savage

Crossings Travel across the river was a necessity and challenge for the first settlements on the river and all those that followed. Rina Swentzell was a Pueblo woman whose ancestors have lived on the banks of the river for nearly a millennium. Her essay, a parable about the river's potent spirit, illuminates her people's connection to the river. The photographs of indigenous bridges across a turbulent river illustrate the elegant, ephemeral adaptations of indigenous people to their environment. As Swentzell notes, the sturdier bridges become, the more our awareness of the potency of the river fades.

Trade Juan Estevan Arellano lived his entire life in the home of his ancestors by the Río Grande, in northern New Mexico. In his essay introducing images of commerce, he writes of the Camino de Agua he lived along—the river road, an ancient trade route. The route was also called the Camino Real—the Royal Road—and it was a corridor for explorers and Indo-Hispanic settlers from the south. The images show trade by horseback and mules at first, then railroads and roads, even steamships in the lower reaches. Trade hugged the river, allowing cities to spring up along a river of commerce.

Cultivation G. Emlen Hall's essay traces changes in farming practices in the valley—slow change in the old regime, rapidly accelerating into industrial farms and plantations with the great control structures on the river. For the earliest people in the valley, the essential crops were a trinity of corn, beans, and squash. Hispanic cultures brought Eurasian staples: wheat, onions, sweet melons, and fruit trees. When twentieth-century instruments of modern engineering emerged, virtually the entire river was harnessed for irrigation.

Flooding The sometime placidity of a tranquil Río Grande, gently meandering across its floodplain, belies the river's savage temper during times of flooding. Again and again, torrential rains raced across the landscape, pouring into the riverbed and swelling into raging floods that wiped out pueblos, villages, railroad tracks, and bridges. Estella Leopold, distinguished paleobotanist and daughter of the great conservationist Aldo Leopold, leads us through images of the river in a wild and destructive mood. The Río Grande might be considered a natural hazard if it were not also the source of life and sustenance in an arid region.

Los Insurrectos The Río Grande, where it forms the border between Mexico and the United States, has a long-term history of conflict and violence.

Laura Gilpin, *The Rio Grande Nears El Paso del Norte*, 1945. The Río Grande meanders across a broad channel for much of its course, changing its bed with frequent floods. Where the floodplain widens near El Paso, a boy and his mule stand on a dike built to keep the river within its banks during high water, protecting fields of cotton and orchards of pecans. Laura Gilpin, *The Rio Grande Nears El Paso del Norte*, 1945, gelatin silver print, P1979.134.102, Amon Carter Museum of American Art, Fort Worth, Texas.

Norma Elia Cantú writes of border politics and the volatile and tragic history reflected in images of a shifting and disputed boundary. Photographs of revolutionaries, soldiers, and guards reveal the tensions of cross-border conflict, while the dispossessed struggle across the river on mules, fleeing bullets.

Big Bend In a huge arc of river bend in southern Texas, the Río Grande enters a seared landscape of deserts, mountains, and Chihuahuan grasslands. Here, the Río Grande cleaves through an arid land to form deep, sheer-sided canyons and formidable rapids. It is a harsh landscape, where early settlers scratched out a living from hardscrabble mines and longhorn cattle ranches. Jan Reid, a historian of the region, gives a sense of the austerity of this still-remote landscape in his essay introducing images of Big Bend.

River's End The river comes finally to the embrace of the sea. The Río Grande once tumbled, now trickles, into the Gulf of Mexico. In closing the collection, Dan Flores, whose books astutely describe the cultures and landscapes of the American West, reminds us that we are all "river rats." And that we all inhabit a watershed, wherever we reside.

For those of us who live near her, the Río Grande allows us to survive. Once dynamic waters are now tamed and diverted. But the water in our glasses still comes from the river and the deep waters that lie beneath in aquifers. The peaches we eat in summer swell and ripen with water from her watershed. The rains and snows that fall in the mountains provide the bathwater we step into. In truth, the river's water runs in our very blood. We depend on the river for life itself as much as the people in these flickering photographic images do, even as we are less aware of our dependence. Even with fiercely competing demands on her waters, the Río Grande is still a living river with the power to animate an entire valley.

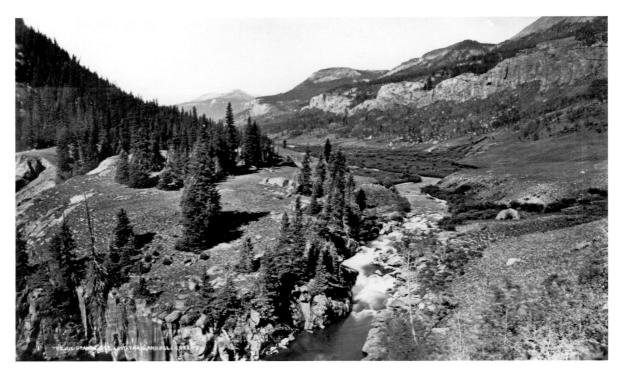

William Henry Jackson, *The Rio Grande between Lost Trail and Pole Creeks, near Carr's Cabin, Looking Up to the Summit of the Range*, 1874. Springs and melting snows spill from the mountains slopes below the Río Grande headwaters in Colorado, converging in the first pristine freshets of the headwaters. Below the summit at 12,500 feet, fir and spruce forests blanket the slopes of the San Juan Mountains. William Henry Jackson, courtesy of the US Geological Survey (Jackson 524).

Introduction

Headwaters | First Thoughts

William deBuys

So much begins with the river.

From snow to shrimp, descending and winding, rolling, sometimes merely seeping across the austere immensity of the Southwest, the river cleaves the land and defines it by the cleaving. The river is where our knowledge of the land begins.

It creates a narrow green corridor, 1,900 miles long, where life springs forth amid desert and near desert, including the life of human communities that have gathered on its banks from the depths of time.

There are other beginnings, specific and unrepeatable. Like the first European settlement in what is now the United States, the outpost of San Gabriel, founded by Juan de Oñate at the confluence of the Río Grande and the Río Chama in 1598. Or the first provincial, later state, capital, Santa Fe, which took root on a side stream of the river less than a decade later.

Or the first federally funded public works in the gigantic territory of New Mexico—newly conquered by the United States—which in the mid-nineteenth century included all of present-day Arizona and much of Colorado and Utah. The earliest appropriations after the US-Mexico War included funds to develop a wagon road along the Río Grande to Taos. Because army engineers carried out the work, the road became known as the Camino Militar.

Not surprisingly, the Río Grande was the subject of the first squabble

over water between the United States and Mexico, which was eventually supplemented by similar contentiousness over the Colorado River. The initial dispute festered through the late 1870s and 1880s as Mormon settlers, following newly laid railroad tracks, poured into the San Luis Valley of Colorado. With great industry, in a few years' time they opened more than three hundred irrigation ditches, all of them fed by the river, and they spread the river's water across the valley. As might be expected, the consequent depletion of flows created big changes downstream. At the divided city of El Paso del Norte (soon to be known as Ciudad Juárez on one side of the river and El Paso on the other), irrigated acreage shrank by more than 50 percent. Scores, perhaps hundreds, of families lost their livelihood and moved away.

Another first was the first mainstem dam to be built on a major western river: Elephant Butte Dam, begun in 1911 and finished five years later. (Roosevelt Dam on the Salt River came slightly earlier, but the Salt is tributary to the Gila, and the Gila is tributary to the Colorado. The Río Grande is tributary only to the sea.) Part of Elephant Butte's purpose was to rectify the situation in El Paso/Juárez by enabling storage and delivery of an assured quantity of water. In the short term, the dam quieted the discord, but inevitably, arguments over use of the Río Grande soon resurfaced. As is the case with every other western river, they continue to the present day.

The harnessing of water at large scale for agriculture and, after that, for generating electricity is the true creation story of the contemporary West. To carry out the task of replumbing half the continent, there had to be a cadre of men, and eventually women, who knew how to measure rivers, quantify their flows, and determine the extent of irrigable lands subtended from their damsites. The US Geological Survey, directed by John Wesley Powell, launched the first school to develop and disseminate these skills. Clarence Dutton, Powell's indispensable lieutenant, chose a site beside the Río Grande at Embudo, New Mexico, where he erected a cluster of tents in the bitter winter of 1888. It was there that such now-familiar terms as "runoff" and "acre-foot" entered the language.

The list of firsts could go on, and one might argue that the Río Grande, having been subjected early on to engineered control and ceaseless litigation, bears the dubious distinction of being the first truly modern river of the American West.

Curiously, the entry of photography into the region and the river's

William
deBuys

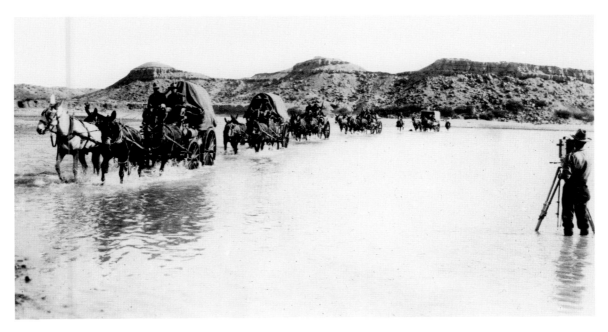

Otis A. Aultman, *Major Langhorne Expedition Crossing the Rio Grande into Mexico at Boquillas*, 1916. Otis A. Aultman, *right*, was the photographer of record for the border conflict across the Río Grande during the Mexican Revolution. US Army troops fording the river in the so-called Punitive Expedition of 1916 unsuccessfully sought to capture Mexican revolutionary Francisco "Pancho" Villa dead or alive. Courtesy of El Paso Public Library, Southwest Collection (065506).

transformation into a tool of industrial agriculture began at about the same time. The metamorphosis of the river has been documented. You see it happening, step by step, in the photographs in this book.

You see the old river, its channel broad and shallow, a nightmare of quicksand. It flooded annually, meandered broadly, and seldom stayed put. This native river carved the land into a shifting mosaic of sandbars and sloughs, ponds and marshes, willow thickets, cottonwood bosques, and braids of flowing water. The diversity of habitats was an ecological marvel, rich with fish curiously adapted to tepid temperatures, scant oxygen, and frequent murk, and rich also with otters and herons that preyed on the fish and with countless other furred and feathered creatures, which slunk through the brush and flitted in the trees. In autumn, when cranes trumpeted their strange *garonk* and gabbles of geese and ducks echoed in the dusk, the cacophony of life along the river was the lone loud thing that might be heard within the rim of the world, from one blue mountain to another.

The river in those days was a terror when it flooded, sweeping away homes and bridges, burying fields and irrigation works in silt, and then adding to the insult of damage by meandering away and leaving the old works high and dry. The Texas historian Walter Prescott Webb famously said that the American West was "a semi-desert with a desert heart," and the West was therefore an "oasis civilization" (Webb, "The American West," 25). What he didn't say was that the oases were usually rivers, long and narrow, and the trick of living in the West involved living not just with aridity but with uncertainty, which entailed a kind of constant, lurking danger. The rivers that made life possible, the Río Grande preeminent among them, were moody, capricious, and marvelously powerful.

One of the Río Grande's greatest muscle-flexings occurred in New Mexico in 1941. The river swelled and swelled and eventually drowned Española to its rooftops, inundated downtown Albuquerque, and entombed the entire village of San Marcial in a mountain of sand. Even today, the greatest and stateliest of the cottonwoods that grace the pathway of that flood are members of the class of '41. They germinated, as cottonwoods have evolved to do, in the scour and mud the floodwaters left behind, producing one of the river's greatest ironies: a gallery forest, ostensibly the most nurturing and peaceful of southwestern environments, built from the river's rage.

World War II delayed the region's response to the 1941 flood and to the

William
deBuys

river's general unruliness, but when the response came, it was emphatic. New levees straitjacketed the old meandering river, and dams muted its anger. Reservoirs, drains, canals, and diversions put the river to "work." And so, for hundreds of miles along its length, more vigorously than ever in the past, alfalfa sprang up in fields as green as Ireland, cotton bloomed, chile peppers reddened in the sun, and pecans trees and many other crops sagged with fruit.

Here and there, another kind of harvest was made: almost as soon as the fields were secure, houses—one by one and then whole subdivisions—began to encroach upon them. And why not? Down in the riverside shade, the leaves of the cottonwoods, as wide as a child's hand, blunted the heat; even in times of drought, they applauded the breeze with a sound like rain. In his magisterial history of the Río Grande, *Great River*, Paul Horgan describes the Camino Real, the "royal road" paralleling the river, as winding "in and out of cottonwoods, a river grace" (Horgan, *Great River*, 501). To live close to the straightened, harnessed river, now that it was unlikely to erase people from its banks, was to be blessed by a state of grace.

So much begins with the river, sometimes at an individual level. If I may intrude a personal note, my writing "career," such as it has been, began with the Río Grande. The first two articles I published in outlets that someone besides my mother would read were a "Reconsideration" of the Great River in the *New Republic* in 1976 and a screed against Cochiti Dam in *Audubon* a few months later. To my delight, shortly after the appearance of the former, a small package of books by Paul Horgan arrived in the mail, signed by the great man himself. Preparing the second piece led to my first encounter with a new kind of document that the National Environmental Policy Act of 1968 had introduced to the world: an environmental impact statement (EIS). Applied to Cochiti, it examined the reasons for and against the dam. The main argument in favor of the project emphasized the protection of Albuquerque and a score of lesser river communities from a repeat of 1941. Flood control was imperative. A structure had to be built. No one argued much with that.

The plot thickened when the EIS discussed what would happen behind the dam. Originally there were to be only the dam and a big basin to hold floodwaters. But the mavens of New Mexico's economic development said that an empty basin would be a waste. Why not fill it with water so that people could sail and fish, maybe water-ski? Property values would

rise. Lots might be sold (or rather leased, as the land belonged to Cochiti Pueblo), etc., etc. After all, and here the EIS rose to a kind of absurdist poetry, "north-central New Mexico is deficient in open-water recreational opportunities" (deBuys, "Cochiti," 121).

The tone was slightly scolding, which helped obscure the surreal logic. Somehow the reader did not come away angry at Florida for its lack of mountains or Iowa for its absent beachfront opportunities. Yet the authors of the EIS depicted New Mexico as beggarly. A reader fully in the flow of the narrative would think, "Poor lowly, bereft New Mexico. Let's fix this!"

Fix it they did, and Cochiti Lake was born, although the EIS did a rather shabby job of forecasting the consequences. It correctly stated the obvious—that the new reservoir would drown a splendidly wild and archaeologically rich canyon—but it missed the fact that a delta of sandbars would form within the canyon, upstream of the lake, and become a new and important, albeit tamarisk-choked, wildlife oasis. Less happily, the EIS failed to grasp that seepage from the reservoir would waterlog Cochiti Pueblo's best agricultural lands, which lay immediately below the dam, producing dire consequences for the pueblo's ancient corn-farming traditions. It also failed to analyze the transformation of downstream aquatic habitat, which dam outflows rendered colder and clearer. A formerly silty and aggrading riverbed became cobbled and began to cut into its substrate. In a few years' time, these changes contributed mightily to the loss of habitat for the Río Grande silvery minnow (*Hybognathus amarus*), an endangered species that today is functionally extinct in the wild, in spite of expensive public programs that annually feed tens of thousands of doomed aquarium minnows into the river, demonstrating the presence of the fish "in its habitat."

But all that, so to speak, is water over the dam. The past cannot be retrieved, and competition for the river's water and pressures on its ecological systems continue to intensify. New Mexicans say Coloradans ought to let more water down; West Texans complain that New Mexico holds back too much; and South Texans howl that Mexico is shorting them on flows from the Río Conchos, the Río Grande's largest tributary.

Of course, everyone would be much happier (and better behaved) if it would just rain, and rain a lot, or snow a lot, which would be even better because mountain snowpack is the best possible storage system. But none of that seems to be in prospect. Just lately (2011–2012), New Mexico experienced its driest two years since precipitation records have been kept.

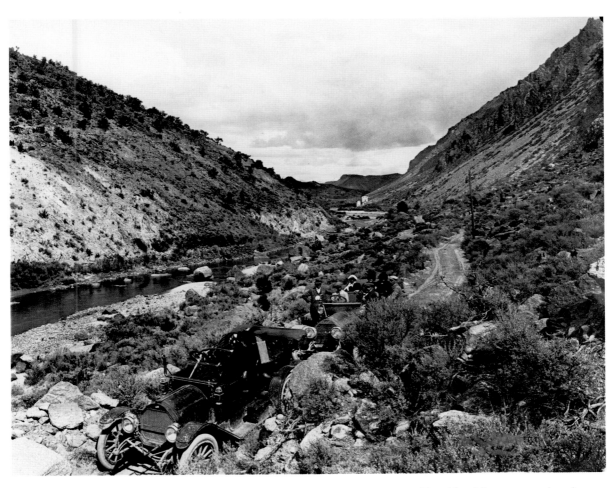

Horace S. Poley, *Road to Taos*, 1910. The early road along the river from Santa Fe to Taos, New Mexico, even though made of rough dirt, brought new life to isolated settlements. A sunny afternoon drew adventurers in convertible cars to the narrow canyon south of Taos. The Denver Public Library, Western History Collection (P-1417).

In the same period, Texas has been grilled, smoked, and hung out like a strip of jerky—to the tune of $5 billion in drought damage in 2011 alone. And northern Mexico has had it worst of all. No wonder everybody is a bit touchy. You can say the cause is climate change, or you can point to the simple odds of returning to the conditions of greater aridity that the tree-ring record says were common in ages past. In either case, you find yourself praying that the withering dryness of current times is just a drought, which is to say, something exceptional, a departure from how things will usually be.

But maybe it is something else. Maybe the mud-cracking, reservoir-shrinking, water-withholding stinginess of recent years isn't an aberration. Maybe, as a fair number of climate modelers have cautioned, it is the new normal.

If so, the Río of the future will be a good deal less Grande than it is now, even beyond its currently reduced and exploited state. But grandeur was never its strong suit. Compared to rivers like the Columbia, the Ohio, and the Hudson, the Río Grande is a trickle. It compares badly even to its southwestern sibling, the Colorado River, which dams have similarly gelded. Next to the Colorado, the Río Grande looks desperately under-nourished.

If the river had feelings, these comparisons would touch a sore point. Americans keep expecting the Río Grande to be something it is not. In 2003, a coalition of environmentalists commissioned a series of focus groups in Albuquerque to assess how people viewed the Río Grande. The results were dismaying. People generally considered the river a disappointment. It was "shallow, tiny, struggling and frequently dry," said the duly consulted keepers of common knowledge. "It never seems to fully fill its banks. It never conducts itself in a stately, picturesque way." The focus groupies evidently carried in their minds an image of what a river should be, and the river that flowed through their city did not measure up. Just as the backers of Cochiti Dam had judged New Mexico to be deficient in open-water recreational opportunities, the Albuquerqueans found that the Río Grande was deficient in Mississippi-ness.

Which makes you wonder about the name Río Grande. Were the Spanish soldiers and colonists who moved north out of Mexico with their Mexican Indian allies, servants, and camp followers mistaken? When they called the quixotic stream that first barred and then sustained their travel "el Río Grande del Norte," did they have a skewed idea of *grande*. They

could not have known that the river before them was the fifth-longest river on the continent or that it carried Rocky Mountain snowmelt 1,900 miles to the Gulf of Mexico. They had no inkling that for the next several centuries, it would be the prize and collision line for the imperial dreams of two emergent nations. And they could not have known that the future biography of the region, an unending duel between society's thirst and the land's aridity, would be written in the saga of the river.

The people who spoke Spanish on the banks of that languid brown stream so long ago had other thoughts. First and most immediately, they knew that the river might drown them and their livestock as they crossed it. More broadly, they knew that the river might later sustain them if they settled beside it, but that just as easily, in a moment's reversal, the river could (and probably would) destroy most of what it had sustained.

The people on the riverbank were desert people. They came from many places, but whether they had been born in Extremadura or Zacatecas, they knew abundantly of stern, dry land. They were experts on scarcity. Having met the river, they were well aware that they had encountered a force that overwhelmingly shaped and determined the possibilities of life. The river was a thing of mystery. Upstream and downstream, it ran farther than could be usefully determined in weeks, perhaps months, of hard travel. It came from the unknown, and it departed to the unknown. It did not explain itself. It simply was.

An early map (1601) gives the river two names: Río del Norte above the confluence with the Río Conchos, and Río Bravo below. The upriver name eventually moved downstream and submerged its competitor. It continued to evolve. In the first decades of the nineteenth century, Río del Norte expanded to Río Grande del Norte, as though to avoid confusion with other rivers of the north. But there having been no other such rivers, it seems reasonable to assume that the insertion of "grande" was more a way of giving the river its due and making explicit a sense people had about it from the beginning. Most Indian names for the river, for example, translate to something approximating "Big River." By the middle of the nineteenth century, possibly as a result of the abbreviating influence of English speakers, some mapmakers had begun to extract "Río Grande" from the longer version, omitting "del Norte," and so the name has come down.

The name Río Bravo, or Río Bravo del Norte, should not be forgotten, for it was well earned—not that *bravo* meant the river was brave, which

is a misfired translation, but because the river was wild and temperamental, frequently as fierce as it was otherwise calm. The *río* asserted itself as a spirit and a force; it dwarfed all human pretension. Were it not for the vehement strictures of the One, Holy, Catholic, and Apostolic Church, the people who called it bravo would not have been stretching things to regard it as a god.

The land was vast. The mountains that rose out of it were grand, and there was no limit to them. The deserts that spread before them were similarly grand; like the mountains, they had no limit. The one great and seemingly animate presence within that universe of sun, wind, mountain, and desert was the ribbon of brown water that stitched so much tracklessness together and gave the land the little bit of a center it possessed. As those early namers so perfectly understood, the río, viewed in its place and understood in relation to the immensities that surrounded but failed to dominate it, this river, this ribbon of life, this Río was unquestionably Grande.

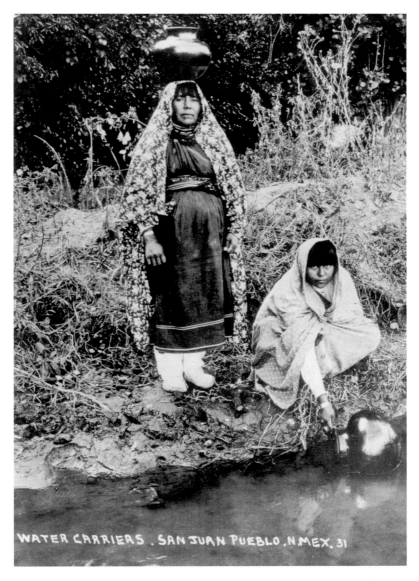

WATER CARRIERS . SAN JUAN PUEBLO .N.MEX. 31

Unattributed, *Water Carriers, San Juan Pueblo, N. Mex.,* ca. 1900–1929. Women from San Juan Pueblo, now known as Ohkay Owingeh, fill their earthenware pots with water from an acequia. After centuries of living by the tumultuous waters of the river, Pueblo peoples learned to divert the steadier flow from the upland arroyos and streams to irrigate their crops. The Denver Public Library, Western History Collection (X-30336).

Crossings

Rina Swentzell

Not long ago, the Avanyung, or the Water Serpent, lived in a small hollow not far from the Posongeh, the Río Grande, between the pueblo of Santa Clara and the town of Española. A spring trickled in that place, creating a tiny pool and making the ground around it damp. A huge cottonwood tree shaded the water, small lizards, grasses, and people. Sightings of the Avanyung, a large serpent with a horselike head, horns, and a snake body, were regularly reported by the Santa Clara Pueblo people until the late 1960s, when the spring gradually stopped trickling and the ground around it dried and hardened. One of the last sightings was by a woman who lived on the north edge of the pueblo. She reported seeing and hearing the Avanyung alongside the pueblo creek, moving toward the Posongeh ("Big Water Place" in Tewa). It was abandoning the small hollow and heading toward the Posongeh, back to its source, a short half mile to the east.

According to Santa Clara people, the retreat of the Avanyung back to the Posongeh signaled the coming of ill times. The promises and blessings of rain and water for the land were being withdrawn. The Avanyung, which has the form of flowing water, can dwell in water places, on land, and underground. It connects earth and sky, underground and above ground, because it is of both. The joining of these opposites creates motion and life. Clouds and moving water are associated with its being. The Avanyung is well-known throughout the dry, harsh lands of the American Southwest and Central America. There

are pictographs of the serpent everywhere in this vast region as well as in the Santa Clara Canyon, which is sculpted by a small but fast-moving creek flowing out of the Jemez Mountains. The Santa Clara Creek joins the Posongeh near the dried spring where the Avanyung once lived.

The original home of the Posongeh is where the Avanyung first emerged from the underground. "The Avanung may have gone all the way back, by now, to the springs in Colorado," says an elder of Santa Clara Pueblo. For Pueblo people, where water emerges from the ground is of great significance. Shrine places are often located there. These watery places, or springs, are where we connect with the underworld, and it is where we, people, also emerged. It is where we came from and where we return when we die. "In that place, we breathed water and not air," a man from Santa Clara says. Pueblo people from Taos to Acoma agree on the spiritual significance of water—water from springs, rivers, lakes, and clouds. "Water is the source of life," they say. It is the source, and it carries us into and through this life.

The Posongeh, the Big Water, springs from the ground up north, moves south in its Avanyung form, and is certainly a life-giving energy for our part of the world, for our watershed. It blesses all beings as it flows through canyons, valleys, villages, towns, and cities. But its energy is complex. It is at once gentle, nurturing, treacherous, and dangerous. It is a great natural force. Children at Santa Clara Pueblo are admonished never to go to the river alone—out of both respect and caution. They are known to disappear. The physical and mystical powers of the river are well-known and honored by people who have lived alongside it for thousands of years. It contains movement that can destroy, cleanse, and heal. The Pueblo people collect its waters for healing ceremonies. It gives life to people, birds, and plants. Irrigation ditches connect to it like blood vessels in our human bodies and provide water for thirsty fields of beans, corn, chile, fruit trees, and alfalfa.

Crossings over the river near Santa Clara Pueblo are few. Before Spanish and Anglo times, there were many native communities on both sides of the river. These people interacted with each other by walking or swimming across at places where the river was shallower and slower at times during the year. They knew the ever-changing nature of the Posongeh and adjusted their crossing places accordingly. Sometimes, simple triangular-type post and beam constructions raised the crossings above the water. At other times, as in the San Felipe area, post pillars included woven wicker pilings, which held up beams or logs, giving

Rina
Swentzell

single-person passage. There were no wheeled carts, cars, trucks, or large animals to urge across the swiftly flowing water.

Sometimes the native communities settled at places along the river where the water was more amenable to crossing. The original pueblo, known as Yungeh-Owingeh, and the present-day village, Ohkay Owingeh, are both located near where the Chama and Río Grande merge. The rivers run shallower there. The old Pueblo people lived in the natural environment and knew where and when the river ran wide and shallow. Crossings happened with intense awareness, respect, and knowledge of the river's personality.

When the Spanish and Anglos arrived, bridges were constructed in places that were beneficial for people, their vehicles, and their loads of belongings. Some of the new bridges were built at old crossings. As wagons and cars and trains came into use, more complex crossings were built. Materials used in construction progressed from native wood posts to manufactured wood beams to metal and steel trusses anchored with concrete. They became permanent, multiple-vehicle crossings. Today, in our everyday crossings of the river, consciousness of or interaction with the power and beauty of the river is negligible.

Even so, the river's beauty is impressive. Recently, I walked from my house to the Posongeh, following the route the Avanyung supposedly took on his crawl back to the river. As I walked on the dirt road, clouds of fine dust flew up around my feet. The ground was intensely dry. Trees and plants were limp. We were in the heat of a multiple-year drought in northern New Mexico. The road distorted in front of me. The air was gray from fires burning on mountain ranges on either side, the Jemez and the Sangre de Cristo.

As I moved through the smoke- and dust-laden air, I caught a whiff of dampness! I was near the juncture of Santa Clara Creek and the Posongeh. Soon there were countless green trees, cottonwoods, tamarisks, and willows. The sound of water, gurgling and rushing, took me into a world so different from the cracked-earth place where I live, only a few miles away. There were lush grasses along the bank of that snakelike being we call the Posongeh. Two ducks were startled. They screeched and fluttered to the other side of the river. A soft, moist breeze blew across the water. I stood amazed at the motion, beauty, and form of that powerful being. It knew itself. It flowed vigorously and with dignity. I knew that the Posongeh and the Avanyung were really one, and I hoped that someday they would share their motion, grace, and blessings with the land and people again.

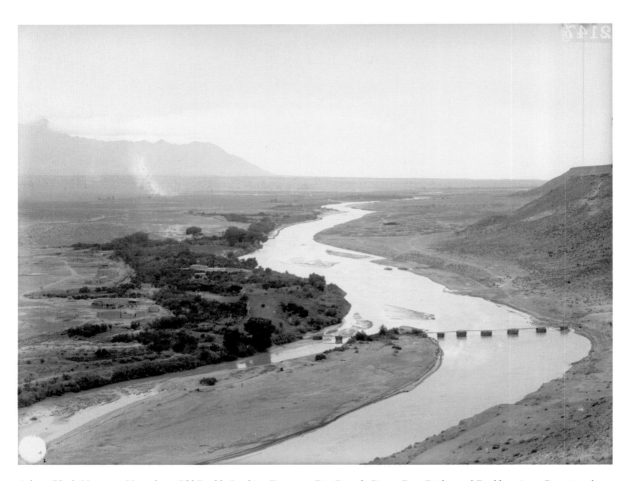

Adam Clark Vroman, *View from Old Pueblo Looking Down on Rio Grande River, Foot Bridge and Pueblo*, 1899. Crossing the sometimes turbulent river was an ancient necessity. The indigenous bridge spanning the river at San Felipe Pueblo used driftwood from riverbank cottonwoods, woven together into pillars and connected by planks. National Anthropological Archives, Smithsonian Institution (BAE GN 02147B 06359200).

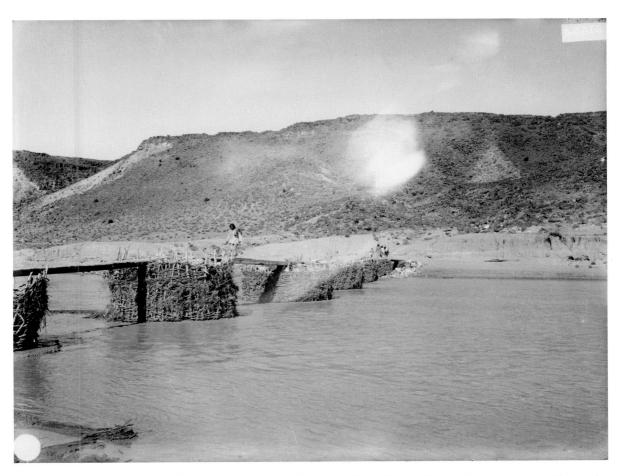

Adam Clark Vroman, *Native Wooden Foot Bridge Spanning Rio Grande River; Group of People Crossing*, 1899. Pueblo people built driftwood bridge pillars, also known as basket caissons, which allowed the river to flow through, yielding to, rather than resisting, the force of the river. National Anthropological Archives, Smithsonian Institution (BAE GN 02146A 06358900).

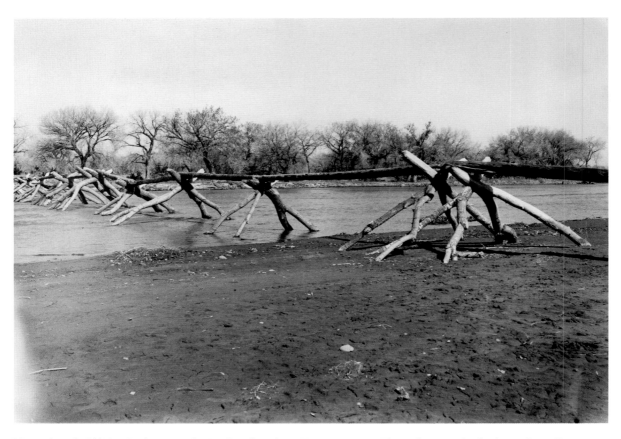

Unattributed, *Old Foot Bridge across the Rio Grande at Santo Domingo*, 1936. This indigenous footbridge at Santo Domingo Pueblo, now know as Kewa, stretched two hundred feet across the river. Long tree trunks resting on forked beams fixed into the river bottom made a stable but flexible bridge. Courtesy of the Maxwell Museum of Anthropology, University of New Mexico, New Mexico, Unattributed (87_44_42).

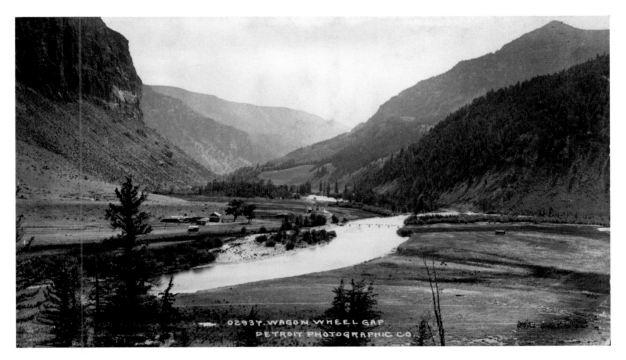

William Henry Jackson, *Wagon Wheel Gap*, ca. 1882–1900. High in the mountains of Colorado, an infant Río Grande runs as a stream through Wagon Wheel Gap. The valley boomed in the late nineteenth century, when gold was struck in the surrounding San Juan Mountains. A thread of a bridge is visible in the center of the landscape. The Denver Public Library, Western History Collection (WHJ-597).

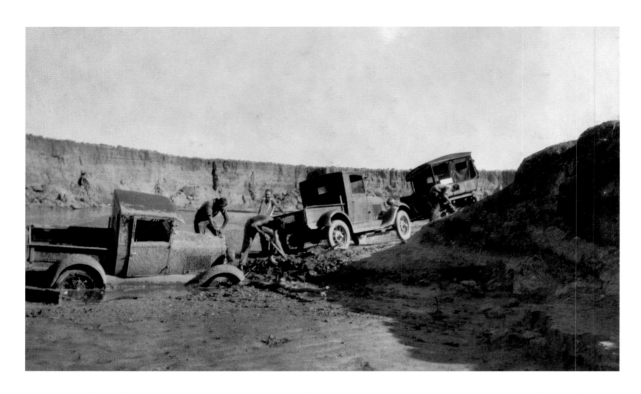

J. W. Wyckoff, *Caught in the Quicksand at Ojito Crossing of the Rio Grande*, 1932. The mention of quicksand brings the word "treacherous" to mind. The Río Grande is an excellent example of the dictum "A mile wide and a foot deep, too thin to plow, too thick to drink." A heavy load of fine sediment created a river bottom that could suck hoof, foot, and wheel. J. W. Wyckoff, courtesy of the US Geological Survey.

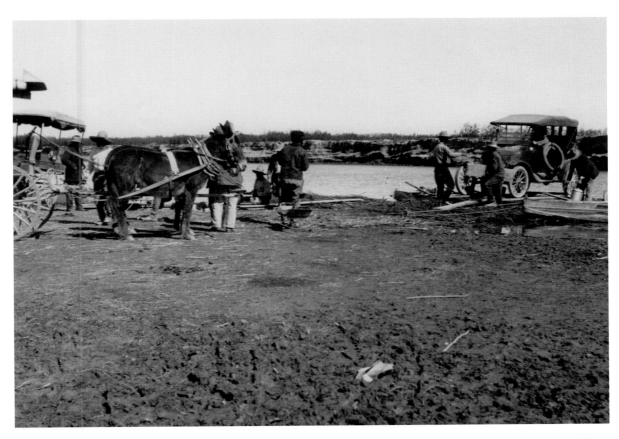

Wilfred Dudley Smithers, [Ferry Docking with Ford at the Rio Grande, Lajitas, Texas], 1921. The little Texas town of Lajitas was a boomtown in the 1800s, when local quicksilver mines and silver and lead mines in Chihuahua made it a major river crossing into Mexico. Here, a ferry docks with the Model T Ford of a Texas mining man returning from the mines of Chihuahua. Photography Collection, Harry Ransom Center, the University of Texas at Austin.

Unattributed, *Otowi Station and Edith Warner's House on Old Highway Showing Denver and Rio Grande Railroad Bridge*, ca. 1940. When she opened a tearoom, Edith Warner could not have anticipated that her home, in the old train depot by the Otowi Bridge, would become world famous. In 1943, the bridge provided the only access to Los Alamos, New Mexico, during the Manhattan Project of World War II, and Warner served Robert Oppenheimer, Enrico Fermi, and other physicists working on the crash program to create an atomic weapon. Unattributed, courtesy of the Palace of the Governors Photo Archives, New Mexico History Museum (NMHM/DCA) (021180).

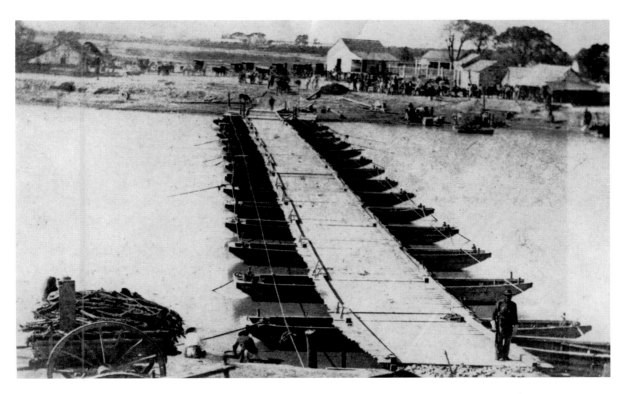

Unattributed, *Pontoon Bridge across Rio Grande to Santa Cruz*, ca. 1866. Floating bridges had a distinct advantage on a river whose water level was so dynamic. This pontoon bridge linked Brownsville, Texas, and Matamoros, Mexico, at the mouth of the Río Grande. It was built in 1866 by the US Army, sent to ensure peace on the US side of the river during the French and Austrian challenge to the rule of Mexican president Benito Juárez. *Pontoon Bridge across Rio Grande to Santa Cruz*, Brownsville Historical Society.

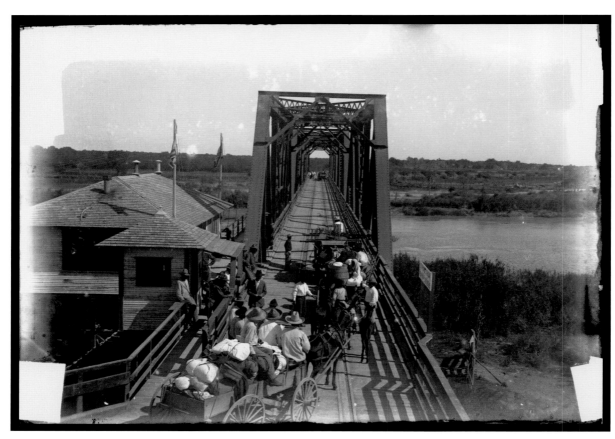

Robert Runyon, *International Bridge*, ca. 1900–1920. Vital trade between Brownsville and Matamoros, near the mouth of the river, led to the construction in 1910 of one of the first major international bridges across the Río Grande. Built as a swing bridge to open for boats, it was finished just as the last of the steamboats disappeared from the river. It opened only once. Robert Runyon Photograph Collection, RUN03751, the Dolph Briscoe Center for American History, the University of Texas at Austin.

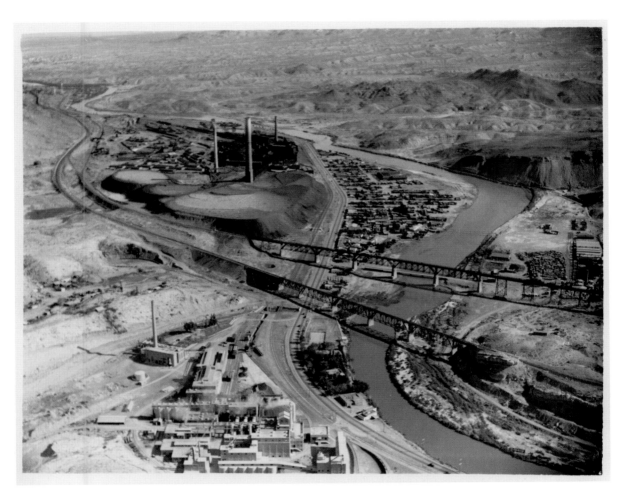

Wilfred Dudley Smithers, [Aerial View of the Smelter near El Paso], 1935. The smelter at El Paso was built in 1887 to process ore from the rich copper and lead mines in Mexico and the US Southwest. It was surrounded by La Esmelda, or Smeltertown, a community of mostly Mexican workers that grew up around the largest employer in the city. Two railroad bridges cross the river, bringing ore from Chihuahua. Photography Collection, Harry Ransom Center, the University of Texas at Austin.

Trade

Juan Estevan Arellano

The Río Grande has been a great road of commerce for hundreds, if not thousands, of years. The prehistoric Southwest had a far-flung network of commercial routes, and the river road served as a crucial artery of trade and cross-cultural exchange. The early cultures of the north sent salt, furs, semiprecious stones, flints, pottery, and, most prized of all, turquoise downstream, and the urban south sent cotton textiles, turtle shells, seashells, obsidian tools, cacao, and other luxury goods upstream. Mesoamerican traders who traveled north carrying backpacks stuffed with seeds and precious ceremonial goods may have been the archetype for the Kokopelli figure of rock art, the famous humpbacked flute player.

After 1598, the "Royal Road to the Interior" followed these same old north–south trade corridors between the populous Pueblo Province of New Mexico and central Mexico. To traverse the great deserts of the region, the route became, by necessity of thirst, a kind of water road following the most constant source of water.

Thanks to the Río Grande, settlers under the Spanish Crown were able to move huge herds of livestock and exotic varieties of vegetable seeds and orchard trees all the way north to "la Nueva México," as the region was known in colonial times. Large grazing animals—horses, mules, cattle, oxen, goats, and sheep—changed the face of the landscape forever, largely

by bringing with them (in their manure) their favorite varieties of exotic grasses.

Transportation for trade in the northern reaches of the watershed was powered at the time by mules, oxen, and horses. In the nineteenth century, trade took to the river itself, and navigation thrived in the lowest reaches, with more than two hundred steamboats plying the treacherous, shifting currents between its mouth and Río Grande City, Texas. During the Mexican-American War, from 1846 to 1848, steamboats from the Ohio and Mississippi Rivers were moved to the Río Grande, transporting US Army supplies to General Zachary Taylor for an invasion of Mexico. Although army engineers suggested that the river could be made navigable as far north as El Paso, those recommendations were never acted upon. Steamboat trade faded by the beginning of the twentieth century. The old steamboat *Bessie*, photographed docked on the riverbank in 1890, was one of the last of her breed.

As soon as the US-Mexico border was drawn, trade in international contraband began. The two countries tried, largely in vain, to control the commerce of the borderlands. Opportunities for enterprising people of the border were too lucrative to resist. At different times, contraband has consisted of textiles, manufactured goods, livestock, alcohol, and, in our own time, illicit drugs and traffic in human beings seeking a better life. All have crossed over the muddy Río Grande. Smugglers are ingenious and were traditionally celebrated for their defiance of the state. Now they are increasingly despised for the violence they bring to the border. Government interdiction of contraband is documented here in a photographic record of both smugglers and border agents.

Over the long time scale, the real commerce on the Río Grande was its agricultural produce, whether it was livestock, cotton, alfalfa, pecans, chile, onions, or beans. In the deserts of the Big Bend region, wild plants were also valuable—the useful wax of the candelilla shrub, and distilled spirits such as sotol, from agave plants.

In the late nineteenth century, railroads opened the watershed to broader-scale commerce. One tributary of the great river, the Río Embudo, became a supplier of railroad ties to the fledgling railroads, seen in the photograph of floating logs jamming the river. This trade devastated the forest above Peñasco but provided employment to local men at a time when there was little work to be had. The railroad ties were used to lay

Juan
Estevan
Arellano

tracks for the Denver and Río Grande Railroad, known as the Chili Line, which ran from Santa Fe to Antonito, Colorado, between 1886 and 1941. The small train moved chile and orchard crops during the summer months to southern Colorado.

My uncle recounted to me his adventures in the chile trade during his teenage years. Our grandfather Tomás Archuleta would put him on the train at the Embudo depot, about two miles from where he lived, with a load of green chile. He would get off at Antonito and sell his produce, and he would remain there throughout the growing season, as my grandfather would send a new load of chile every week. At the end of every growing season, he would once again make his trek home to Embudo.

The waters of the Río Grande permitted cities such as Albuquerque, Las Cruces, and El Paso to flourish in a verdant valley, while either side of the river is a desert. The Río Grande is life in this arid landscape, for without water, there is neither agriculture nor trade.

Unattributed, *Rio Grande*, no date. Traders ply the road south of Taos, itself a crossroads of old trade routes east and west, between the mountains and plains. Traders traveled along a northern branch of the Camino Real, the ancient trade route along the river, carrying wool, weavings, buffalo hides, beaver pelts, piñon nuts, and salt south into Mexico, and livestock, iron tools, luxury goods, and silver north into its provinces. Unattributed, courtesy of the US Geological Survey.

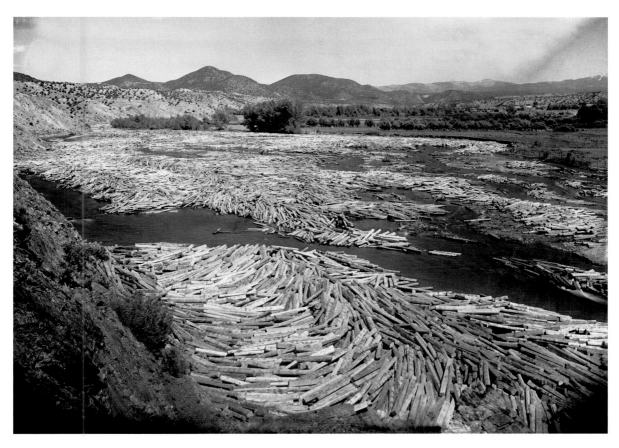

Unattributed, *Log Jam on the Rio Grande River, New Mexico*, ca. 1915. Pine forests across northern New Mexico were heavily logged to provide railroad ties to the Denver and Río Grande Railroad. Thousands of ties were required for every mile of track. Loggers built temporary dams across the river and then breached them to release a surge of water, which floated logs downstream to mills. Figures of lumberjacks riding the ties are visible in the distance. Unattributed, courtesy of the Palace of the Governors Photo Archives, New Mexico History Museum (NMHM/DCA) (039350).

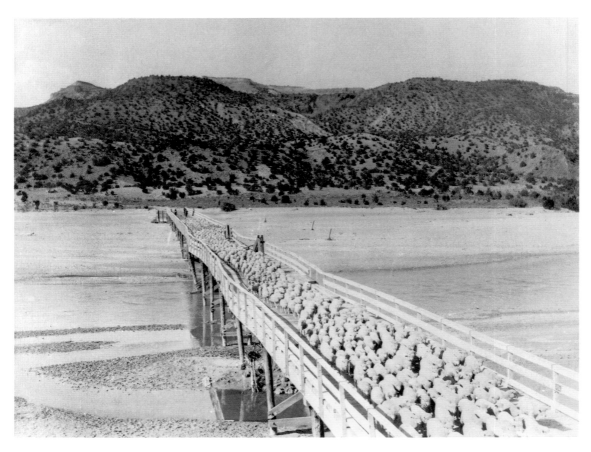

Unattributed, *Sheep Crossing Buckman Bridge*, 1922. West of Santa Fe, the Río Grande flowed between the railroad and the Jemez Mountains, rich in timber and lush meadows. Entrepreneur Harry Buckman built a bridge across the river in 1900 to transport timber from Spanish land grants in the mountains to a sawmill by the river. Here, sheep are driven to join thousands of others in high mountain pastures. Unattributed, courtesy of the US Geological Survey.

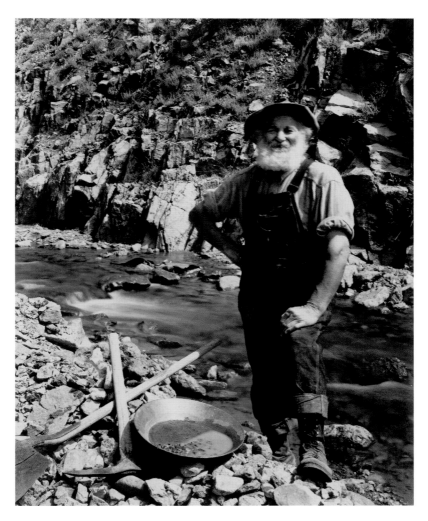

Laura Gilpin, [Inspector Fred Gulzow, Creede, Colorado], 1946. Gold fever
struck the eastern San Juan Mountains in the upper Río Grande watershed in the
1870s. The sheer size of the strikes brought industrial mining to the area. But for
decades, a common sight was the solitary, optimistic gold prospector panning the
river, with only his mule and his dreams for company. Laura Gilpin, [Inspector
Fred Gulzow, Creede, Colorado], 1946, gelatin silver print, P1979.134.35, Amon
Carter Museum of American Art, Fort Worth, Texas.

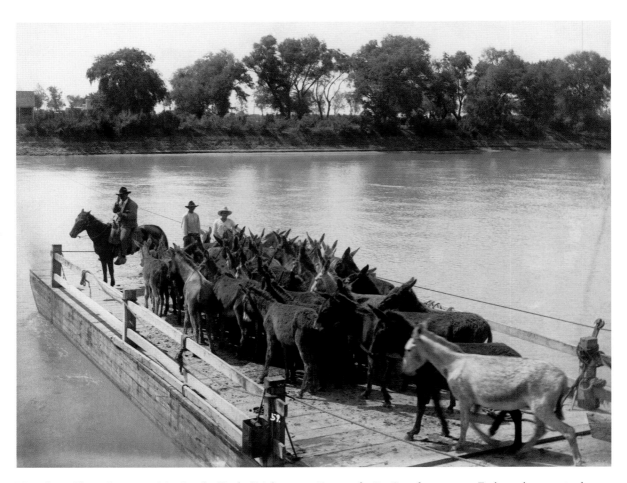

Humphries Photo Company, *Men Load a Herd of Mules onto a Ferry at the Rio Grande*, ca. 1910. Early settlements in the border region were built on the brawny backs of mules. Tough, surefooted, and reliable, mules were an important mode of transport in South Texas and throughout the Southwest. After the Civil War, teams of ten mules pulled heavily loaded wagons—called prairie schooners for their white, sail-like canvas tops—in long convoys across the prairie. © Humphries Photo Company/Corbis.

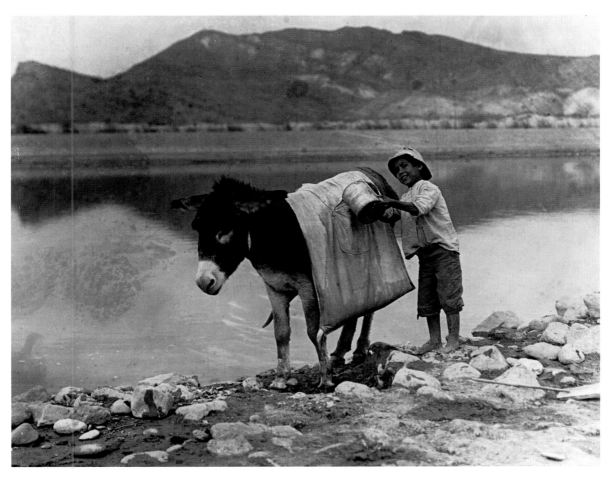

Wilfred Dudley Smithers, [Mexican Boy Filling a Large Canvas Bag with Water], 1917. This young Mexican boy sold water to households near Presidio, Texas, in an ingenious contraption in the days before water delivery. The burro carries a canvas water bag sealed with candelilla wax, with a spigot devised from fitted pieces of cow's horn sewn into the bag. Customers left the water, muddy from the river, to stand in containers until clear enough to drink. Photography Collection, Harry Ransom Center, the University of Texas at Austin.

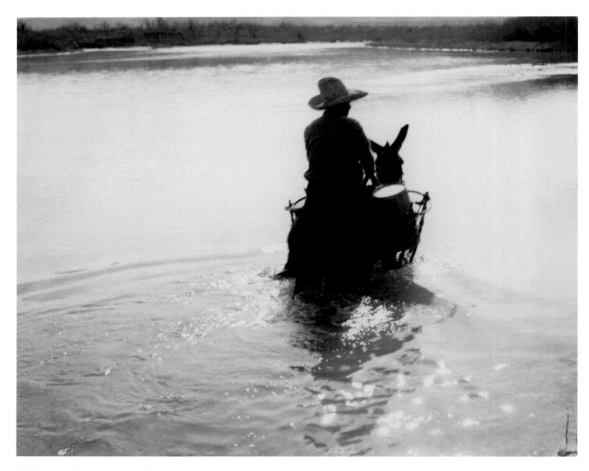

Wilfred Dudley Smithers, [Mexican Crossing the Rio Grande near Presidio, Texas], 1930. During Prohibition in the United States, a lively smuggling trade in sotol, a Mexican agave liquor, took place across the river. The heart of the sotol plant was roasted and fermented to make a liquor similar to tequila. This trader crosses the river on his mule near Presidio, Texas, with two five-gallon kegs of sotol. Photography Collection, Harry Ransom Center, the University of Texas at Austin.

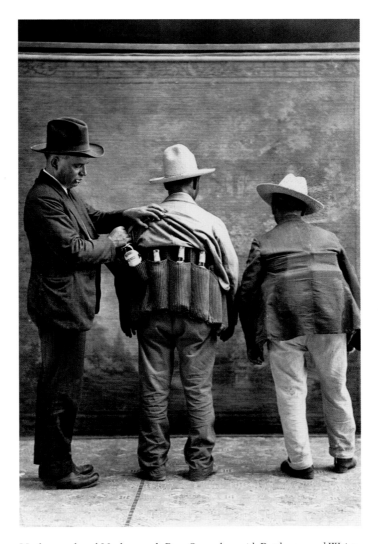

Underwood and Underwood, *Rum Smugglers with Bottles around Waists*, 1923. These two unlucky, if resourceful, Mexican sotol smugglers were nabbed by US customs officials after crossing the Río Grande. The authorities were successful in capturing few Prohibition-era smugglers, who customarily crossed the river at night. © Underwood and Underwood/Corbis.

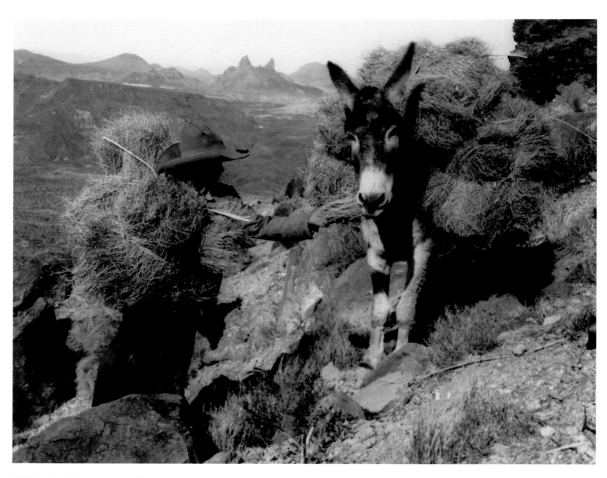

Wilfred Dudley Smithers, [Zacatero with Burro and Chino Grass], 1930. Commerce in chino grass, a type of grama grass, was essential in the early twentieth century in the arid border region. Hay traders, or *zacateros*, gathered wild grama grass in Mexico and ferried bundles across the river as the chief forage for the horses of the army cavalry, Texas Rangers, and ranchers. Here, a *zacatero* hands his burro a bite of grass on Pinnacle Mountain, Texas. Photography Collection, Harry Ransom Center, the University of Texas at Austin.

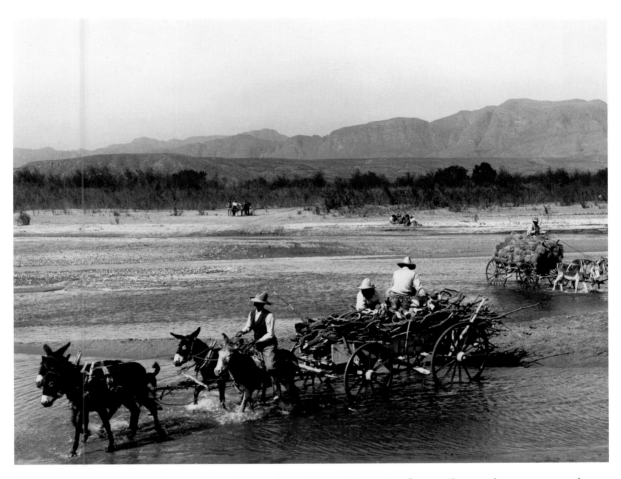

Wilfred Dudley Smithers, [A Wagon Load of Stovewood and One of Chino Grass], 1916. On port days, once a month, Mexican traders brought wagonloads of grama grass for livestock forage and stove wood across the Río Grande into Texas. Fort Davis alone contracted for tons of fodder and firewood each month. Photography Collection, Harry Ransom Center, the University of Texas at Austin.

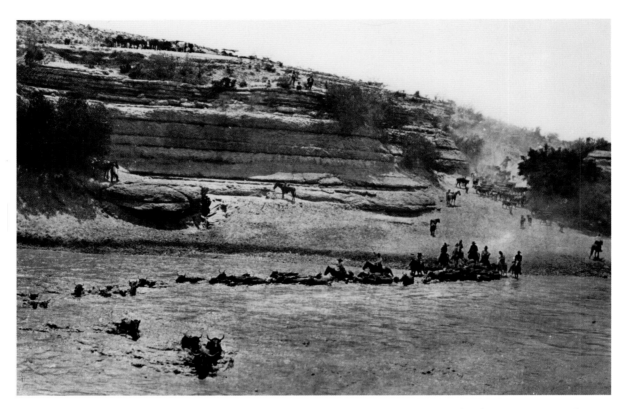

Wilfred Dudley Smithers, [Cattle Swimming across the River], no date. In the 1860s, the first big drives were organized to deliver cattle to the new railheads in Kansas. Mexican cowboys, or vaqueros, were already experienced in such feats, and they passed on their expertise to American cowboys. The "Corrido de Kiansas [sic]," a narrative ballad from the era, extolled vaqueros' familiarity with the river. Photography Collection, Harry Ransom Center, the University of Texas at Austin.

Bajamos al Río Grande,
no había barco en que pasar.
El caporal nos decía,
"Muchachos, se van a ahogar."
Los vaqueros le responden
todos en general,
"Si somos del Río Grande,
de los buenos para nadar."

We went down to the Río Grande,
there was no boat in which to cross.
The foreman cried,
"Boys, you're going to drown."
The cowboys replied
all together as one,
"But we are from the Río Grande,
the ones who are good swimmers."

(Lamadrid, "El Sentimiento Trágico," 43)

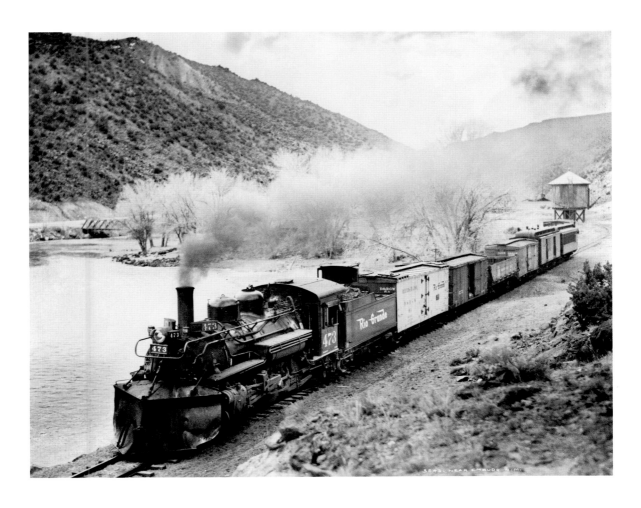

Louis Charles McClure, *Near Embude (Embudo) N.M.*, ca. 1941. The settlements of the canyons in northern New Mexico were relatively isolated until a narrow-gauge railroad was completed along the river in 1886. The Chile Line carried sheep, cattle, chiles, beans, and timber out, and flour, sugar, and other supplies into the region. It was abandoned in 1941, when transport by road became more efficient. The Denver Public Library, Western History Collection (00073245).

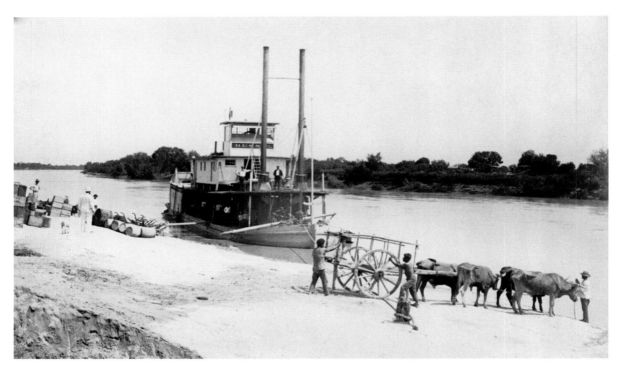

Unattributed, *Steamship Being Loaded on Rio Grande*, ca. 1890. Steamboats were an important mode of transport on the lower Río Grande during the US war with Mexico in the 1840s. Navy and commercial boats patrolled the border and ferried troops and supplies. But shoals, shallows, and shifting river depths made navigation tricky. Here, the stern-wheeler *Bessie*, last of the riverboats in the area, takes on cargo at Fort Ringgold, Texas, around 1890. © Corbis Images.

Cultivation

G. Emlen Hall

Water is a mirror that reflects all that surrounds it. Look at it closely—especially in a desert, where it is precious and scarce—and you can tell everything about the society that manages it. The landscape also reflects water. Cultivation is essential to human life in the desert, and water is essential to cultivation. Ever since the invention of agriculture, there has been cultivation in the deserts of the Río Grande watershed. The spirit of human survival reveals itself clearly in the photographic record.

Along the Río Grande's long course, from the mountains of Colorado to the marshes and meanders of the delta, seasons of planting and harvest come at different times. At its headwaters, the growing season is squeezed between a late last-spring frost and the first frost of fall. In the river's southernmost reaches, the growing season is yearlong. Spring-summer is eternal.

For more than a millennium, human survival in the valley depended on seeds that worked their way north from central Mexico. Crops were watered in resourceful and artful ways. Dependable water for crops was the vital attraction of the Río Grande for settlements along its banks. The history of human intervention in the name of cultivation is incised everywhere on the face of the watershed—in the river itself, in its riparian areas, and in its uplands. Modern structures—the huge, strangely beautiful

flood-control dams and concrete diversion channels—bespeak the need to control the river for cultivation.

The more modern the intervention, the more apparent its physical manifestation. The older, subtler waterworks, like acequias, hew to the contours of the land but are still visible, especially from the air. The most ancient water-control structures of all, stone catchments in arroyos and cobble gardens, point to a simple rule: getting water to seeds is indispensable.

Other signs of cultivation are more ephemeral. From their arrival around AD 1000, the farmers of Cochiti Pueblo used the Río Grande waters to cultivate corn. Every year, they selected accessible islands in the constantly shifting flow of the braided river. There they planted corn. If they guessed right, a spring pulse in the river washed over the island at just the right time and in the right amount to germinate the corn. Thereafter, the underflow of the receding river would supply the water needed for the growing crop and for a fall harvest. Risks of planting along a wild river were balanced with prayer. Sometimes there was simply no harvest.

Community acequia systems brought by Indo-Hispano settlers in the sixteenth century supplemented Pueblo cultivation techniques. Water was diverted into canals to broaden the riparian zone and irrigate lands between the acequias and main channel. The first acequia was dug in the summer of 1598 near the confluence of the Río Grande and the Río Chama, not far from the village of San Juan Okay Owingeh. The canals provided the water essential to sustain nearby towns and villages. They were the central artery of community life. With population growth, the land was divided into narrower and narrower "long lots," running perpendicular from the ditch to the river. Acequia landscapes supported a rich biological diversity, in contrast to the stark uplands immediately above them.

US rule brought a new, more aggressive style to cultivation in the Río Grande Valley. Nowhere is this better exemplified than with the "monster ditches" established in the 1880s in Colorado's San Luis Valley, far upstream from the old pueblos. In a matter of a few years, corporate farmers put almost 600,000 acres into new cultivation, mostly with grains to feed the new and burgeoning cattle market. These ditches were the harbingers of a new kind of cultivation because they were not contoured to the shape of the land. As the Laura Gilpin photograph of the San Luis Valley shows, they ran straight as far as the eye could see. They introduced the linear world of industrial cultivation.

G. Emlen
Hall

The downstream world of ancient acequia landscapes and subsistence cultivation shuddered. River flow slowed down. Flash flooding sped up. The level of the riverbed rose as new layers of sediment were deposited. To avoid salinity, fields now required drainage, where before they had needed only irrigation. By the mid-1920s, more than half of the 140,000 irrigated acres in the middle Río Grande had gone out of cultivation.

In response, the water masters brought even more technology to the river. Elephant Butte Dam, downriver from Socorro, New Mexico, clearly represents this spirit. Designed primarily to settle interstate water disputes between Colorado, New Mexico, and Texas, the dam was also supposed to resurrect a farming community in the El Paso–Las Cruces area. The region had fallen on hard times because of the scarcity of water, caused in part by Colorado's new diversions in the San Luis Valley. The beautiful, massive dam rose up from the bedrock, and the water it stored regularly flowed down onto fields and crops.

The new, more secure Elephant Butte water supply transformed the world of farming below the dam. In effect, Texan and southern New Mexican farmers had traded water insecurity for financial insecurity. Farmers now had to pay for their share of the Elephant Butte project, and they had to raise those additional funds from the existing subsistence agriculture. Everything changed overnight—ownership, farm sizes, and, most significantly, crops. Forced into cash crops to pay new debt, farmers switched to cotton for the first time—with ambiguous and uncertain results. Cotton cultivation was not as secure as they had imagined.

Agricultural lands above the new dam suffered the same fate as the lands below, and the response was the massive Middle Rio Grande Conservancy construction project of the 1930s. Large concrete irrigation structures replaced primitive ones. But there were huge costs in southern New Mexico and West Texas—social and hidden ones—as entire ancient subsistence communities were disrupted by the new cash economy that moved in. From ditches to dams, from ancient sustainable gardens to industrial-scale production of grass and grains for cattle, the waters of the Río Grande have entwined with cultivation for centuries. The landscape bears the visible marks of their history.

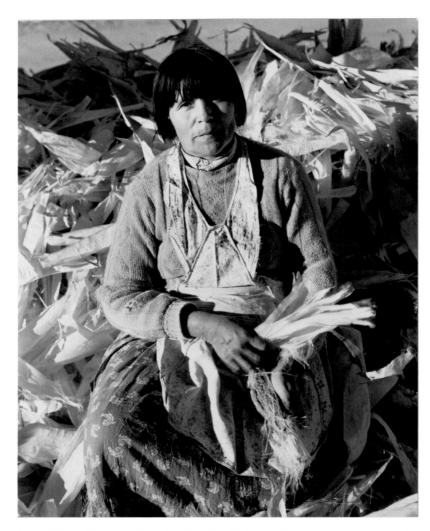

Laura Gilpin, [Husking Corn, San Juan Pueblo], 1947. No crop was more central
to Native American life in the Río Grande Valley than corn. Brought on trade
routes from Mexico in ancient times, corn, beans, and chiles, together with
squash, sustained native settlements for more than a millennium. Laura Gilpin,
[Husking Corn, San Juan Pueblo], 1947, gelatin silver print, P1979.134.212,
Amon Carter Museum of American Art, Fort Worth, Texas.

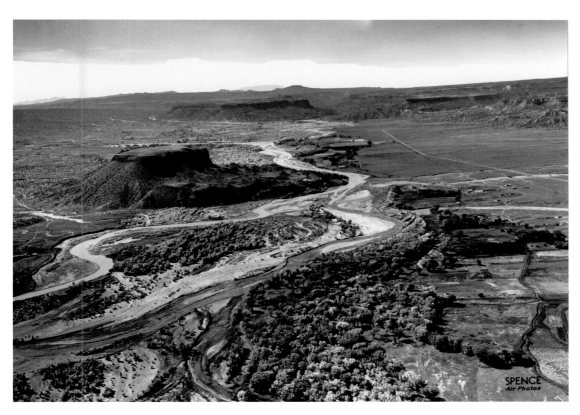

Spense Air Photos, *Oblique Aerial of Landscape and Farm Fields*, 1939. The Río Grande meanders across its wide channel in northern New Mexico, shifting its bed laterally over time. The cottonwoods and willows of the bosque, the ribbon of forest along the river, are adapted to the variable, dynamic water flow. The ancient pueblo of San Ildefonso lies on the right of the river, and the sacred Black Mesa is near the center of the image at left. Courtesy of the Maxwell Museum of Anthropology, University of New Mexico, Spense Air Photos (92.01.712).

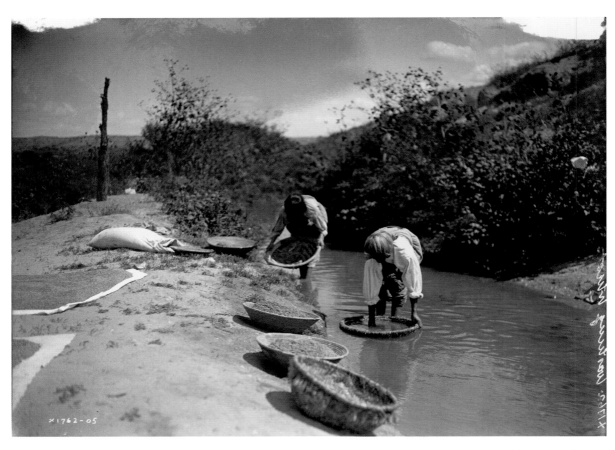

Edward S. Curtis, *Washing Wheat, San Juan*, 1905. Two women from San Juan Pueblo, now known as Ohkay Owingeh, clean baskets of wheat by submerging the grain in an acequia, allowing the water to carry off straw, chaff, and dirt. Edward S. Curtis, courtesy of the Palace of the Governors Photo Archives, New Mexico History Museum (NMHM/DCA) (031249).

Tyler Dingee, *Aerial View of San Ildefonso Pueblo*, ca. 1950. The pueblo village of San Ildefonso was built away from the riverbanks, safe from flooding. Pueblo cultivators drew water from the river and arroyos into fields of corn, chile, squash, and beans. After the Spanish brought the irrigation technology of canals to the Southwest, indigenous and Hispanic communities meticulously maintained these acequias for centuries. Tyler Dingee, courtesy of the Palace of the Governors Photo Archives, New Mexico History Museum (NMHM/DCA) (074175).

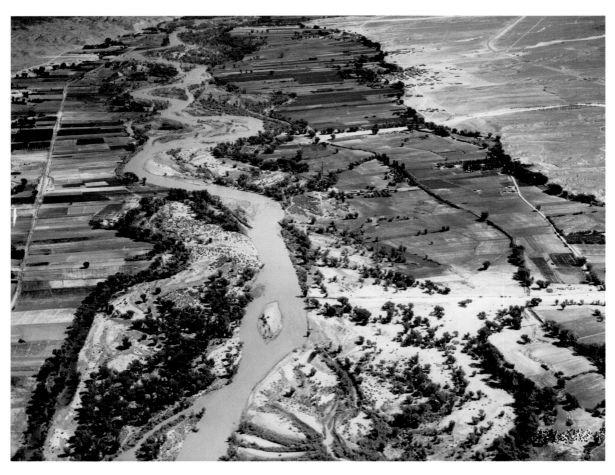

Unattributed, *Rio Grande River at High Water Stage, Velarde, New Mexico,* 1937. The long, narrow strips of cultivated land reflect a Hispanic tradition of dividing land equally among heirs. Near Velarde in northern New Mexico, the valley is a patchwork of lush farms and fruit orchards. The Río Chama, whose confluence is on the right, augments the flow of the Río Grande. Unattributed, courtesy of the Palace of the Governors Photo Archives, New Mexico History Museum (NMHM/DCA) (147563).

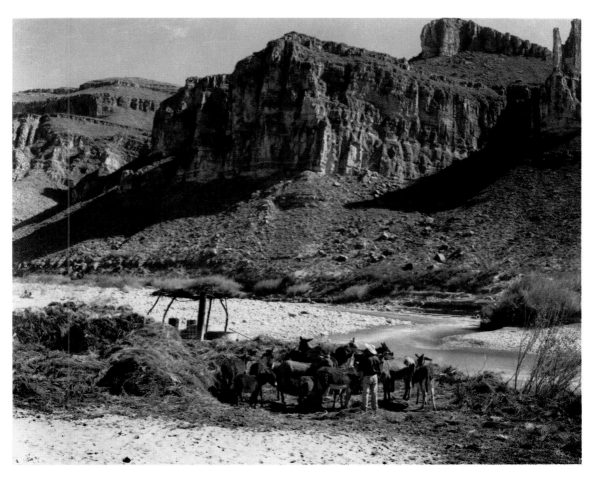

Glenn Burges, [Candelilla Wax Factory], no date. Wax produced by candelilla shrubs was at the center of a booming small-scale industry along the lower canyons of the Río Grande in the early twentieth century. Wild plants were gathered, packed on burros, and sent to portable rendering operations by the river. The plants were boiled in large vats and the wax skimmed off the surface. The wax had many uses, from waterproofing munitions in World War I to fueling Big Bend quicksilver retorts. Archives of the Big Bend, Bryan Wildenthal Memorial Library, Sul Ross State University, Alpine, Texas.

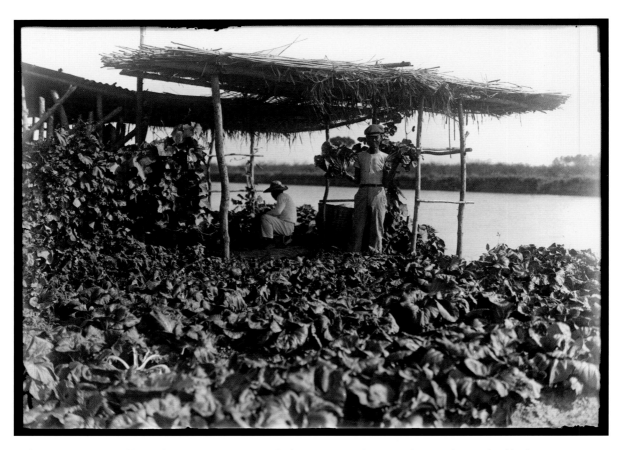

Robert Runyon, *Vegetable Garden*, ca. 1900–1920. A plucky pioneering farmer smiles over his patch of leafy greens, irrigated with waters from the muddy lower Río Grande. In time, the lower valley in Texas, blessed by mild winters and abundant river water, would become a powerhouse of agriculture, driven by citrus, cotton, corn, rice, and sugarcane. Robert Runyon Photograph Collection, RUN03420, the Dolph Briscoe Center for American History, the University of Texas at Austin.

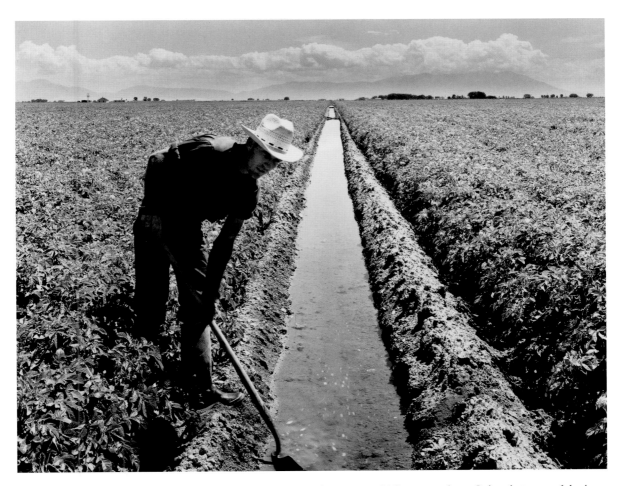

Laura Gilpin, *Irrigation in the San Luis Valley, Colorado*, 1946. The San Luis Valley in southern Colorado is one of the largest alpine valleys in the world. Beginning in the nineteenth century, vast diversions of water from the river made possible the large-scale cropping of potatoes, barley, and hay. The valley was relatively isolated until a railroad was built in the 1870s, making it possible for the harvest to be shipped to markets. Laura Gilpin, *Irrigation in the San Luis Valley, Colorado*, 1946, gelatin silver print, P1979.134.119, Amon Carter Museum of American Art, Fort Worth, Texas.

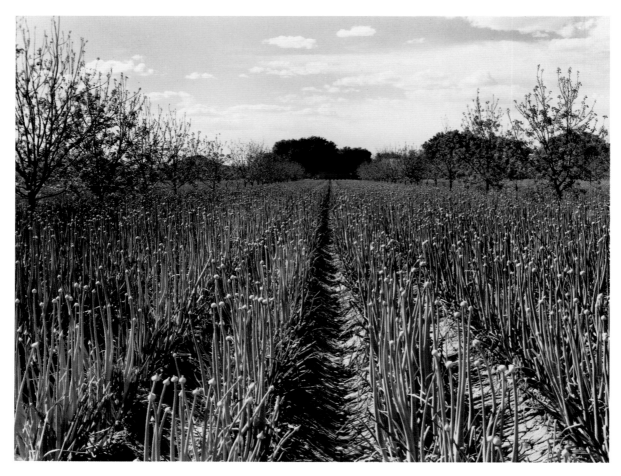

Laura Gilpin, *Seed Onions in a Pecan Orchard*, 1947. The miracle of harnessed water transformed the high, dry San Luis Valley into high-elevation cultivated fields of onions and vegetables and orchards of apples and pecans. The promise of agricultural bounty brought first Hispanic and then Mormon, Dutch, and Japanese settlers. Laura Gilpin, *Seed Onions in a Pecan Orchard*, 1947, gelatin silver print, P1979.134.109, Amon Carter Museum of American Art, Fort Worth, Texas.

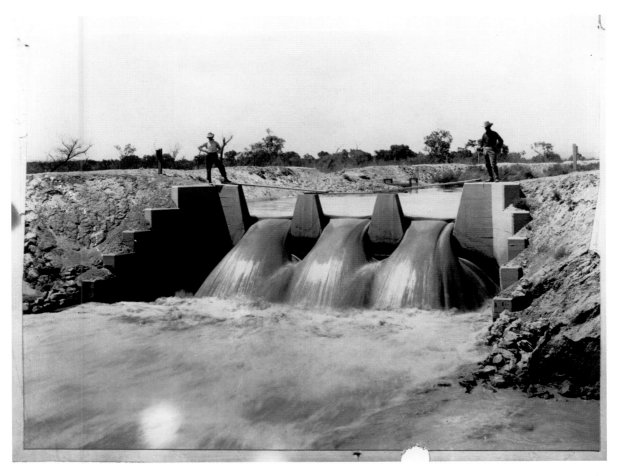

Otis A. Aultman, *Irrigation*, no date. By the mid-1800s, dikes, canals, and small dams had begun a more systematic use of river water for agriculture. Eventually, thousands of small irrigation structures, like this three-pronged diversion dam, put the waters of the river to work. Courtesy of El Paso Public Library, Southwest Collection (A5559).

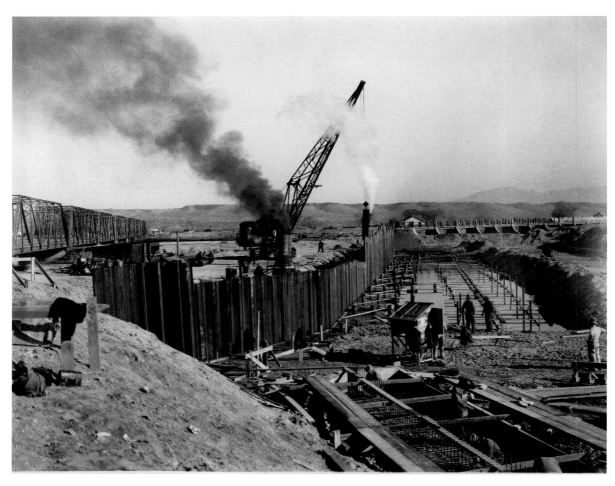

Unattributed, *Belen Highline Canal (Construction)*, 1933. The Rio Grande Project was a massive irrigation and flood-control project that took the first fifty years of the twentieth century to build. Canals, dams, and drainage channels diverted vast amounts of water to fertile but arid lands. The web of structures, such as this dam and head gate of the Albuquerque Canal, under construction in central New Mexico, often drained the Río Grande dry in southern portions of its run. Courtesy of the Middle Rio Grande Conservancy District, New Mexico (all rights reserved), 017-No. 353, Plate XIV.

Flooding

Estella Leopold

Rivers have a timeless ability to shape the landscape. One of the most historic and starkly beautiful of river valleys is the long stretch of countryside along the Río Grande. Ever since the Colorado Plateau was uplifted in geologic time, the rivers and streams that drain it flowed eastward and then south. Cottonwoods floated fluffy seeds and set their roots into the floodplain. With snowmelt each spring, a surge of runoff made its way down the breast of the great river valley, picking up silt and moving sand. The waters rose like a tide, periodically covering the cottonwood terraces—the bosques—of the great Río Grande. Here the sandhill cranes spent winter months. Each spring, they would rise in huge flocks and fly north together, seeking their nesting grounds.

After the great Ancestral Pueblo society of Chaco fell on hard times in the twelfth and thirteenth centuries, survivors scattered widely. Some came east to the ever-flowing Great River to found new pueblos. The first Spanish incursion came from the west after Francisco Vázquez de Coronado's armies followed the Pacific coast north in search of the golden cities of Cibola. The only treasure they found was the silvery water of the Río Grande, the most generous river between the Colorado and the Mississippi. They followed the river terraces, camping among the cottonwoods as they went. Coronado reported that the natives tended little flood-irrigated cornfields

on thousands of acres of lower Río Grande floodplains. There were wide marshes, an abundance of fish and fowl, and enough water for agriculture.

Hispanic settlers trailed northward along the river in the centuries that followed. Many were ranchers who, like my ancestors the Lunas with their sheep, built homes well above the bosque to avoid spring floods. They harnessed the waters in acequias, networks of canals that brought water to their gardens. One photo from the Río Puerco Valley shows the demise of a log and brush diversion dam built to irrigate village fields, breached in a 1951 flash flood.

Historians say that up to 1850, Puebloan Indians and Hispanic settlers worked together cooperatively such that the relationship between water use and community development was balanced. After around 1850, as a result of expanding settlements in the San Luis Valley and overgrazing throughout the watershed, the river began to experience sharp seasonal changes. Spring floods rose over the landscape, destroying buildings and forcing farmers and livestock to flee upslope. Erosion created deep arroyos in almost every drainage. The nature of the river was clear to Pueblo Indians, who wisely constructed their adobe buildings above the Río Grande channels.

Two kinds of floods occurred: spring runoff from snowmelt and summer monsoons. Both were irregular and impressive. The high-summer rainfall events resulted from the "Arizona Monsoon," which drifted warm clouds of moisture north from Baja California, bringing afternoon downpours. Those storms were a periodic natural feature of the Southwest, often triggering floods in June and July. Overgrazing removed grasses, causing more frequent and severe floods. The massive flood of 1884 struck the middle valley with an estimated peak flow of one hundred thousand cubic feet per second. A flood in 1937 washed out the town of San Marcial, New Mexico, including its church and railroad tracks. Many feet of mud and silt flooded orchards and buried river terraces and farmlands. The lower delta was prone to large, damaging hurricanes as well. Floods in 1891, 1897, 1903, 1905, 1906, 1907, 1911, 1912, 1914, and 1920 alternated with droughts during which the river dwindled to a trickle or dried up entirely. By 1912, soil surveys reported great expanses of alkali flats in the middle Río Grande Valley. Floodwaters had largely eroded the bosques.

In 1890, John Wesley Powell, director of the US Geological Survey, drafted a policy for the arid lands of the West that would restrain development based on the capacity of the land to support it. Settlers were to be stewards of the land, not exploiters. He presented the plan to Congress,

Estella
Leopold

but unfortunately it was not accepted. Powell's initiative nonetheless led to the establishment of a system of streamflow monitoring gauges that provided essential information for settling the arid West.

Dams were a mixed blessing. Elephant Butte Dam was built in 1915 in southern New Mexico to protect Hispanic farmers, control the river, and provide a steady stream of irrigation waters. After the dam was complete, annual average water flows reaching Presidio, Texas, downstream, were drastically reduced. Below the dam, typical spring flows were replaced by fall flows, altering irrigation systems. The earthen dam built at Cochiti Pueblo leaked, and its impact on downstream soil wiped out traditional agriculture there. A rock sacred to the people of Cochiti Pueblo was submerged, with terrible spiritual consequences.

Flows controlled by dams greatly reduced the transport of sediment by the river. Sediments carried by tributaries now pile up in the main Río Grande channel, since the river does not have enough current to move them downstream. The meandering, wild river has slowed and become confined between levees, elevating its bed above the countryside. By 1937, near the village of Contreras, New Mexico, the elevated river broke through the dikes, and floodwaters drowned agricultural fields. Civilian Conservation Corps crews were put to work in 1941 to keep the dike from being breached again. The return flows from farmlands became saltier. Invasive tamarisk trees flourished in river bottoms. Fish populations declined. Dams and the straightening of the great river meanders have come at a drastic cost.

The US Bureau of Reclamation has suggested that restoration of the river ecosystem—and its bosques—may mean decommissioning Elephant Butte Dam and other downstream dams. Renewal of the river might mean establishing flows that mimic or reproduce more natural spring-flow patterns. Aldo Leopold, former New Mexico resident and conservationist, wrote that the bosques, the grasses, flowers, and cottonwood groves came "near to being the cream of creation"—a remnant resource to be treasured and protected (Leopold, "Conservationist in Mexico").

Leopold wrote, "We think of reclamation as a net addition to the wealth of the arid west. In the Southwest it is more accurate to regard it, in part, as a mere offset to our own clumsy destruction of the natural bottoms which required no expensive dams and reservoirs, and which the Indians cultivated before irrigation bonds had a name . . ." (Leopold, "The Virgin Southwest"). The sandhill cranes would probably agree with such an appraisal.

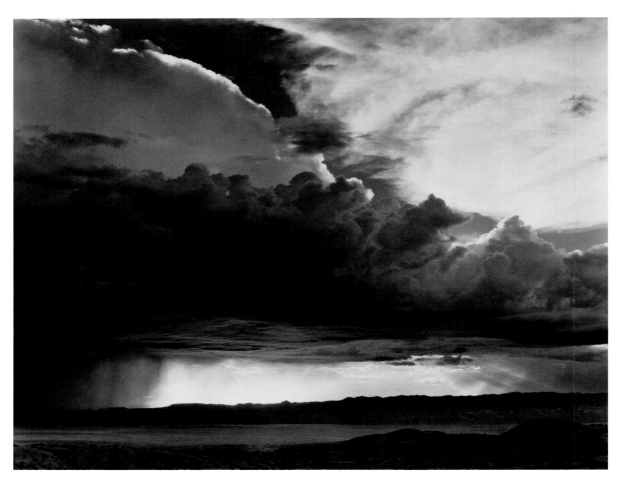

Laura Gilpin, *Storm over the Rio Grande Valley*, 1946. Summer is a time of torrential thunderstorms in the Río Grande Valley. Here, thunderheads build over the valley south of Santa Fe. Storms sent sheets of water flowing over the landscape, plunging through arroyos into the river—which repeatedly overflowed its banks, flooding fields and towns. Laura Gilpin, *Storm over the Rio Grande Valley*, 1946, gelatin silver print, P1979.134.89, Amon Carter Museum of American Art, Fort Worth, Texas.

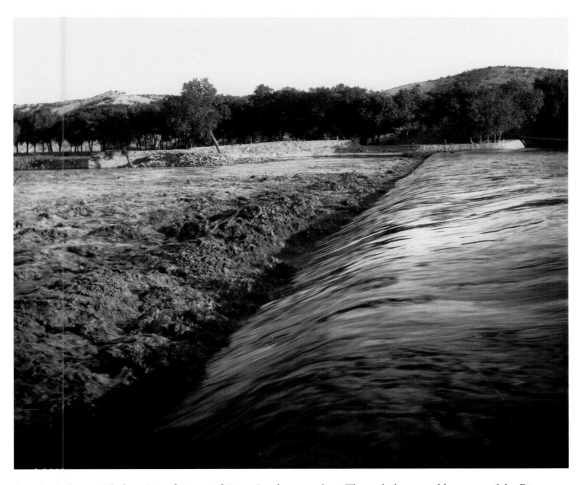

Otis A. Aultman, *Elephant Butte [Diversion] Dam, Leasburg*, no date. The turbulent, muddy waters of the Río Grande flowing over a diversion dam, north of the town of Radium Springs, New Mexico, convey the power of the river. This diversion dam, one of the oldest in New Mexico—it was built in 1908—has seen its share of floodwaters. Courtesy of El Paso Public Library, Southwest Collection (A5307).

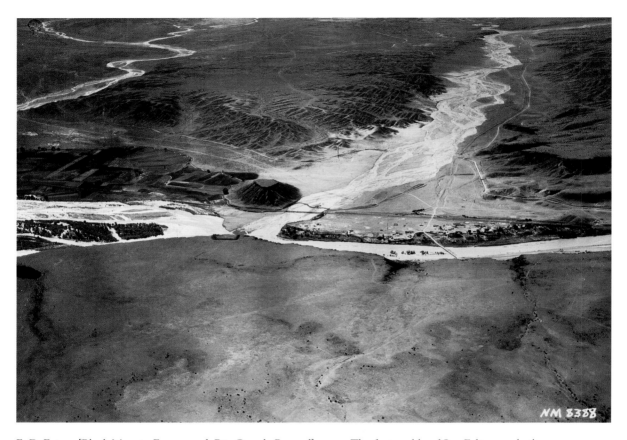

E. D. Eaton, [Black Mesa in Foreground, Rio Grande Beyond], 1937. The first pueblo of San Felipe was built on a mesa overlooking the Río Grande in central New Mexico, but it was moved to the bankside, nearer irrigated fields. Here, the epic 1937 flood fills Tonque Arroyo, in the center of the image, and flows into the Río Grande just above the pueblo. The tracks of the Atchison, Topeka and Santa Fe Railroad, laid alongside the river, are visible at the base of the Black Mesa butte. New Mexico State University Library, Archives and Special Collections.

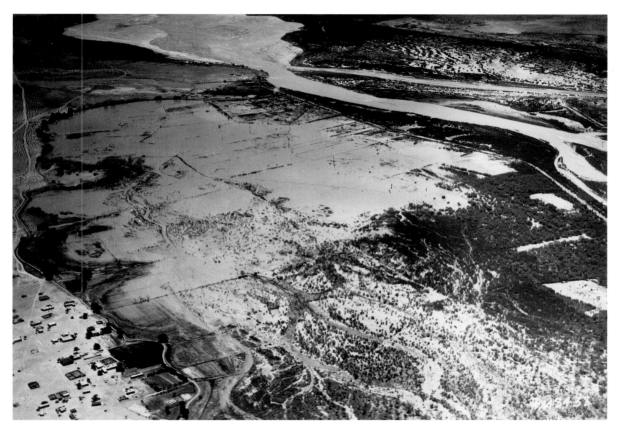

E. D. Eaton, [Looking Down Rio Grande Valley], 1937. The flood of 1937 spreads silvery fingers across the landscape near the village of Contreras, New Mexico, left in the foreground. Dikes along the river had raised the level of the riverbed higher than the surrounding countryside, and rising floodwaters broke though to inundate orchards and agricultural fields. Floodwaters reached for three miles from bank to bank and deposited two to three feet of mud on fields and villages. New Mexico State University Library, Archives and Special Collections.

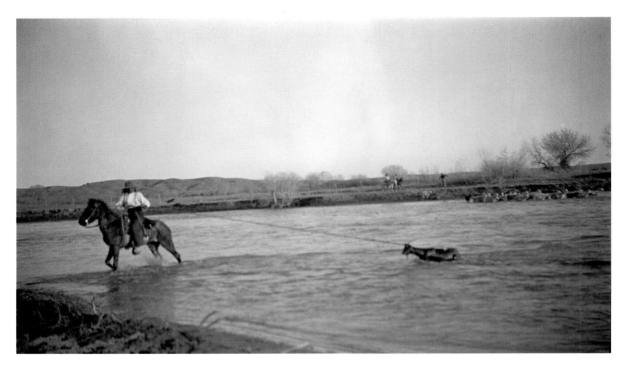

H. F. Robinson, *Man on Horseback Rescuing Goat from Rio Grande River, Cochiti, New Mexico*, ca. 1925–1935. A resident of Cochiti Pueblo, the northernmost Keresan pueblo, rescues his goat from the flood. Irrigation-based cultivation was ancient in Puebloan culture. Historically, the channel was braided, and the river meandered across a broad floodplain, depositing rich sediments across fields. H. F. Robinson, courtesy of the Palace of the Governors Photo Archives, New Mexico History Museum (NMHM/DCA) (072647).

F. Lee Kirby, *Flooded Streets of San Marcial, New Mexico*, 1929. The village of San Marcial, New Mexico, had a tragic history. Settled by Hispanic villagers on a mesa overlooking the river, it was moved to the bankside when the railroad was built. There it was repeatedly flooded, until an enormous flood in 1937 washed out the tracks. The town faded from existence. "El Corrido de San Marcial," a traditional Hispanic ballad, documents the event. F. Lee Kirby, United States Forest Service.

El día viente de agosto,
no me quisiera acordar,
que se llegó el Río Grande
a la plaza de San Marcial
.
¡Ay, qué lástima de pueblo
cómo quedó destrozado!
Por en medio de las calles
lomas de arena quedaron.

—Ramón Luna (composer)
(Loeffler, *La Música de los Viejitos*, 53)

On the twentieth of August,
I don't like to remember it,
the Río Grande flooded
the town of San Marcial
.
Oh, what a pitiful town,
how it was ruined!
In the middle of all the streets
hills of sand remained.

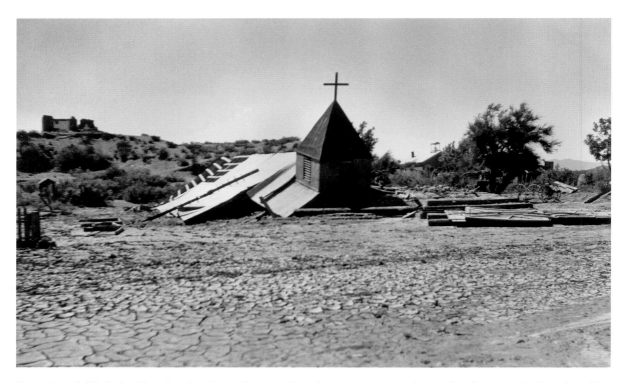

Unattributed, [Catholic Church at San Marcial], 1937. The adobe construction of riverside villages was fatally vulnerable to floods. The soaked Catholic church at San Marcial crumbled in the flood of May 1937. Many villages along the middle Río Grande—San Marcial, Guadalajara, Elmendorf, San Antonito—melted away into the river in the flood and never recovered. New Mexico State University Library, Archives and Special Collections.

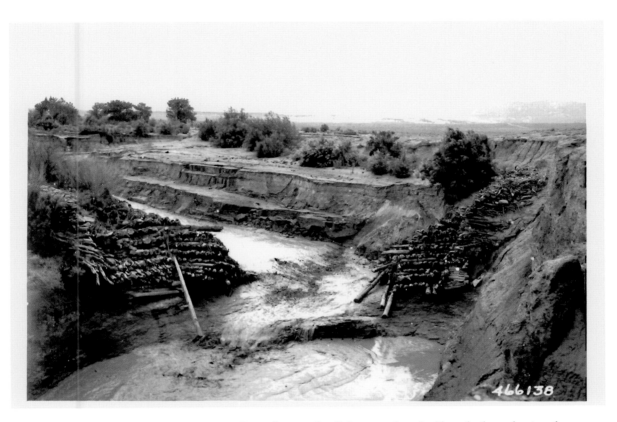

W. L. Hansen, [Pole and Brush Dam on Rio Puerco], 1951. Small diversion dams had been built on the river for centuries to irrigate village fields. This pole-and-brush dam on the Río Puerco, a major tributary of the Río Grande in central New Mexico, was built in 1930 and washed out in a 1951 flood. Thousands of yards of stored sediment were sent tumbling downstream to the Río Grande and into Elephant Butte Reservoir. W. L. Hansen, United States Forest Service.

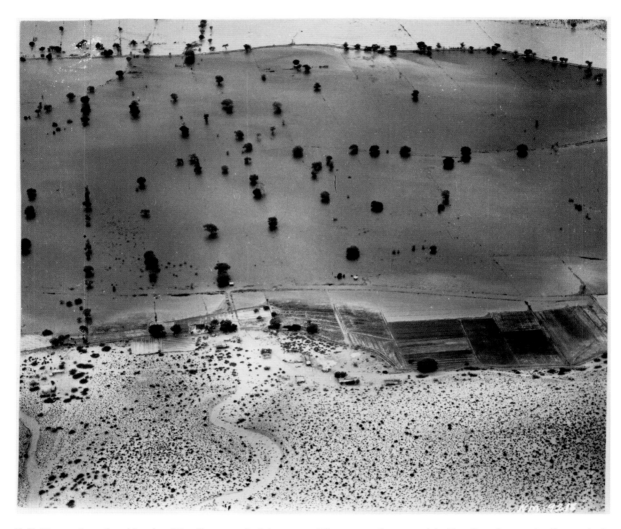

E. D. Eaton, *Agricultural Land and Dwellings near La Mesa*, 1937. The untamed waters of the Río Grande periodically wreaked havoc on settlements built near the only reliable source of irrigation in an arid landscape. Here, orchards, agricultural fields, and farmhouses below Valverde, New Mexico, were inundated in the 1937 flood. New Mexico State University Library, Archives and Special Collections.

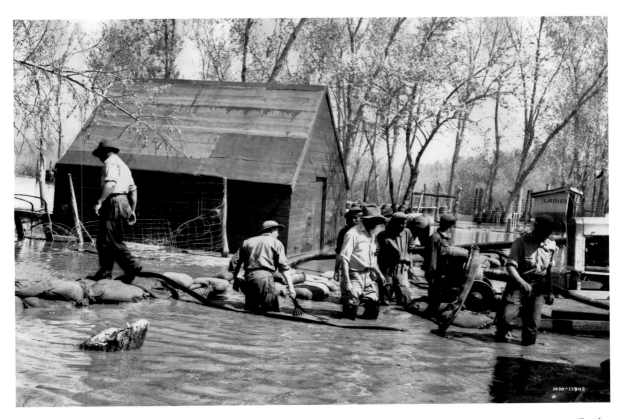

Unattributed, [Civilian Conservation Corps Crew Working on Protective Dyke], 1941. In northern New Mexico, a Civilian Conservation Corps crew works to keep a dike from being breached by the 1941 flood. The accumulated sediment held by dikes along the river had created a riverbed higher than the surrounding farms. New Mexico State University Library, Archives and Special Collections.

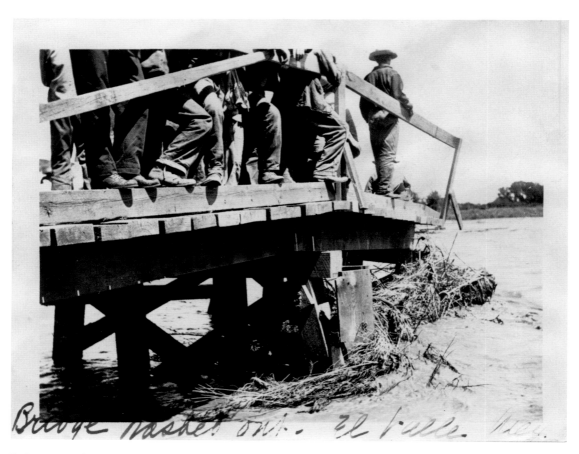

Bridge washed out. El Valle. Mex.

R. J. Farnsworth, *Bridge Washed Out, El Valle, Mexico*, ca. 1916. The lower Río Grande Valley, or El Valle, was really a rich agricultural floodplain extending a hundred miles or so upriver from the mouth of the Río Grande. Besides the frequent floods that came with summer monsoons, the delta area was prone to fierce hurricanes sweeping upriver. R. J. Farnsworth, courtesy of the Palace of the Governors Photo Archives, New Mexico History Museum (NMHM/DCA) (005959).

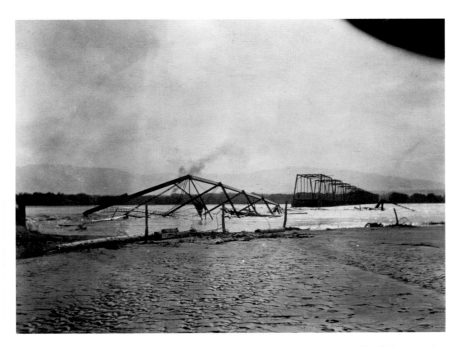

Unattributed, *Bridge Failure on the Rio Grande, Barelas Bridge*, 1903. Bridge failures in the floodwaters of the Río Grande were common. Major floods were documented in 1828, 1865, 1874, 1884, 1903, 1920, 1929, 1937, and 1941. The 1828 flood was estimated at one hundred thousand cubic feet per second by the International Boundary and Water Commission, based on records left by a Catholic priest at Tomé, New Mexico. Here, the Barelas Bridge in Albuquerque was demolished in the 1903 flood. 000-119-0624, Center for Southwest Research, University Libraries, the University of New Mexico.

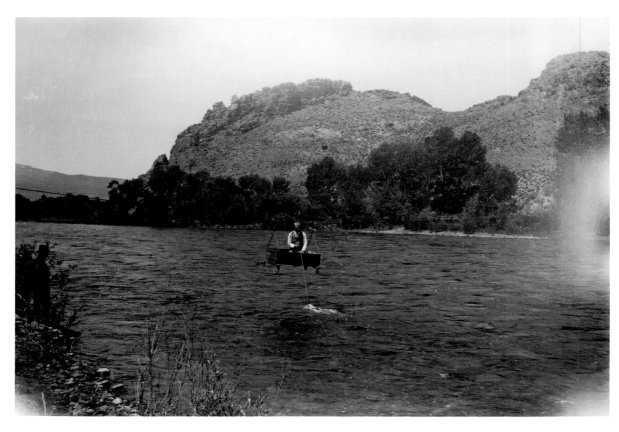

Unattributed, *Gauging Rio Grande River, at High Water*, ca. 1890–1900. A man suspended from a cable over the Río Grande takes flow measurements in Colorado. The first federal water-gauging station in the country was established in 1889 at Embudo, New Mexico, by John Wesley Powell, the great geographer of the West. Powell urged the establishment of a system of streamflow monitoring gauges to provide essential information for settling the arid West. The Denver Public Library, Western History Collection (X-1–21117).

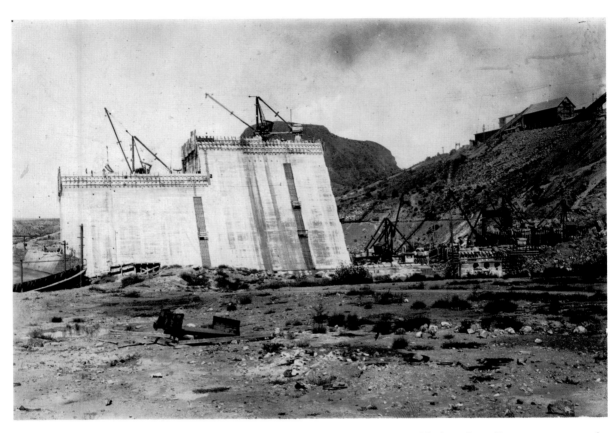

Unattributed, *Construction of Elephant Butte Dam in Southern New Mexico*, ca. 1914. Elephant Butte Dam was constructed in southern New Mexico to irrigate the pecan orchards and chile fields of the fertile Mesilla Valley and guarantee delivery of treaty water to Mexico. Construction began with the 1911 completion of a railroad that ferried supplies and equipment to the site. Huge "plum stones," three to four feet in diameter, were embedded in the concrete to add shear resistance. Unattributed, courtesy of the Palace of the Governors Photo Archives, New Mexico History Museum (NMHM/DCA) (121344).

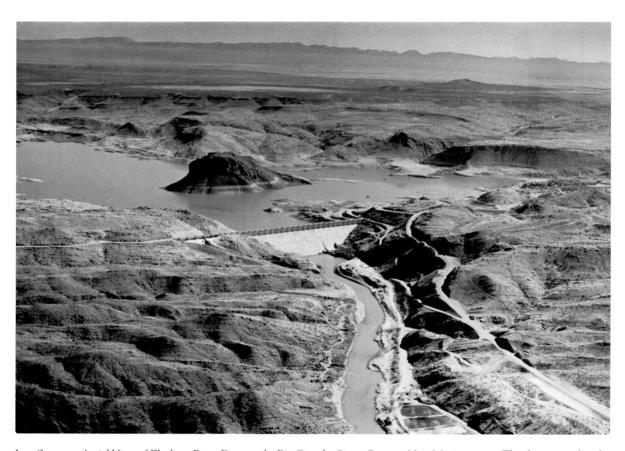

Len Sprouse, *Aerial View of Elephant Butte Dam on the Rio Grande, Sierra County, New Mexico*, 1949. The dam, completed in 1916, is still one of the largest irrigation dams in the world. When full, it created a lake forty miles long in the midst of the parched Chihuahuan Desert, but the huge load of sediment carried by the muddy river is slowly filling the lake. Len Sprouse, courtesy of the Palace of the Governors Photo Archives, New Mexico History Museum (NMHM/DCA) (059167).

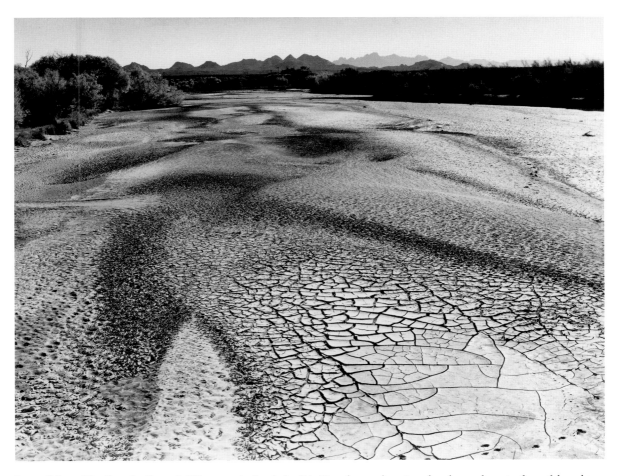

Laura Gilpin, [Dry Riverbed], 1946. When not in flood, the Río Grande can show its other face—the grim face of drought. Heavy withdrawals of water for irrigation in Colorado and New Mexico meant that the river dwindled as it ran south. In drought years, only a cracked mud bed is left for miles, as here in the Mesilla Valley. Laura Gilpin, [Dry Riverbed], 1946, gelatin silver print, P1979.134.27, Amon Carter Museum of American Art, Fort Worth, Texas.

Los Insurrectos

Norma Elia Cantú

A border between nations means history. It means bloodshed and violence. It means military presence. It means lives ruptured. Families rent apart (or joined) by politics and commerce. It means wounds. "*Es una herida abierta*"—it is an open wound—as Gloria Anzaldúa claimed (*Borderlands*, 25), and the scab that signals healing is temporary, as it bleeds time and again and will not heal. Pregnant with stories that have come to term, the border remains a mystery shrouded in a code to be only partially deciphered. It is a place marginalized by the centers—in this case el DF and DC, the centers of power. But one can just as easily reframe that power and see the border marked by a river, in this case the Río Grande—known as the Río Bravo in Mexico—as the place for confluence as well as conflict. The photographs freeze moments in its history. They are memento mori, as Susan Sontag would say. They offer glimpses into the past, revealing parts of a complicated and often-tumultuous past, yet never fully telling the story. The images—of the burning bridge at *los dos* Laredos, Nuevo Laredo and Laredo, and *los insurrectos*, the insurrectionists, at the El Paso–Juárez border—give us a hint at the story. The border is about spectacle, about contemplating *el otro lado*, the other side, as in a mirror.

Los dos Laredos share a history dating back to the 1750s in terms of the Spanish presence in the area. Yet it is obvious why a certain spot between the railroad bridge and the fourth bridge at Colombia is called El Paso del

Indio, the Passage of the Indians. The indigenous groups that migrated seasonally across the river, more than likely Coahuiltecan tribes, saw the river as a source of water. No doubt the crossing existed before Hispanic settlers came, before the cattle-range industry arrived and livestock crossed from one side to the other, before there were steamboats coming up from the Gulf of Mexico, before Laredo became a settlement, a town, a city. No doubt that history was full of grief and sorrow for Native Americans who had roamed the area and found sustenance in the river.

The battles continued when the new border that was created between Mexico and the United States in 1848 made one community two. The opposing political parties, the Botas (the Boots) and the Huaraches (the Sandals), continued to fight in Nuevo Laredo in the late nineteenth century. Yet the Mexican and US cities still functioned as one community, with a common language and a common past. Ultimately, the two opposing forces joined to form the Independent Party, or el Partido Viejo—the Old Party—a political machine that dominated Laredo politics until 1978.

In the history of the border, of the Río Grande, images emerge that coalesce around the central theme of the bridge, of a river where folks stand on either side. The bridge burns in the photo from 1920, and Laredoans stand idly by, watching the destruction of the link between the two communities. Like tourists drawn to a spectacle, people come to the river's edge to see the billowing black smoke. The wind blows the smoke and the stench of wood burning, the heat emanating from the fire. That crisp spring day reminds the citizens of both countries how tenuous the link between them really is.

In the image *Americans and Insurrectos at Rio Grande*, the eye of the camera looks south across the río from El Paso into Ciudad Juárez, where troops are assembling for a battle while American picnickers witness the action from the US riverbank. Mexico is gripped in revolution, and the onlookers are out to observe the spectacle. The object of their interest? The Mexican rebels, los insurrectos, whose uprising changed Mexico in profound ways. The river looks shallow enough to cross on foot. Women and men on both sides seem to be waiting for something to happen. Parents have brought their children to see history in the making. Many have *sombrillas*, or parasols, to shield them from the blazing hot sun, which undoubtedly makes the sweaty bodies milling around relish sporadic breezes.

The bloodshed on the border seems only to have grown worse since the start of the twenty-first century. The bloodshed that had been consistent from the time of the arrival of the Spanish (or perhaps even before, when Lipan Apache and Comanche groups moved into the area in the mid-eighteenth century) later became politically driven. The Mexican Revolution early in the twentieth century and then bootleggers contributed to a violence that became almost a normal state of affairs. The current *narcotraficante* culture of violence so horrific—with beheadings and dismemberments of bodies—is quickly becoming the norm as well. I will not get into the ways in which neoliberal policies have exacerbated how illicit commerce at all levels—including drug traffic—has bled into everyday life on the border, as it did in the past. Images of lynchings and executions have given way to images of cartel violence against immigrants and citizens alike.

Nevertheless, the border is a place of beginnings and endings. It is still being defined and articulated as it was in 1848, when the Treaty of Guadalupe Hidalgo finally settled the dispute and made the Río Bravo/ Río Grande the border. But in the great flood of 1864, the río changed its course southward and gave six hundred acres to the United States. In a 1967 ceremony of peace and cooperation, Mexican president Gustavo Díaz Ordaz and US president Lyndon Johnson celebrated the resolution of the resulting political problem. Land was returned to Mexico, three bridges were built, and the Río Grande was tamed in a concrete channel. In 1992, to commemorate the five hundredth anniversary of European arrival in the Americas, the town of Colombia was founded on a nine-mile-long stretch of Texas land south of the Río Grande. The town sought to compete economically with Coahuila and Tamaulipas in Mexico for the lucrative import-export business. In many ways, the war between Mexico and the United States is still not over. Why else is it that citizens of the *franja fronteriza*—the border strip, along 150 miles on either side of the US-Mexico border—remain so marginalized?

US I-35 turns into Mexican Federal Highway 85 at the border, becoming part of the Pan-American Highway that runs from Alaska to Argentina. The international bridge that binds the two Laredos is part of this highway system, the artery through which goods and people flow north and south. The bridge is essential for the flow to be smooth and uninterrupted.

The river's history takes many turns as the river itself transforms from a thriving, lush, life-giving water source for Native Americans to the dangerous Río Bravo for colonial settlers, and to a life-giving water supply for *fronterizos*—people of the border—on both sides. The 1954 flood washed away the international bridge. What chaos! My parents, stuck on the Mexican side, barely made it back across to our home on the US side. I remember the immunizations against deadly diseases and polio in the months that followed, the pontoon bridge we crossed, and the opening of a new bridge a year later.

The bridges across the river divide, and join, two nations in war and in peace. In my mind's eye, one of those bridges is still on fire.

Norma
Elia
Cantú

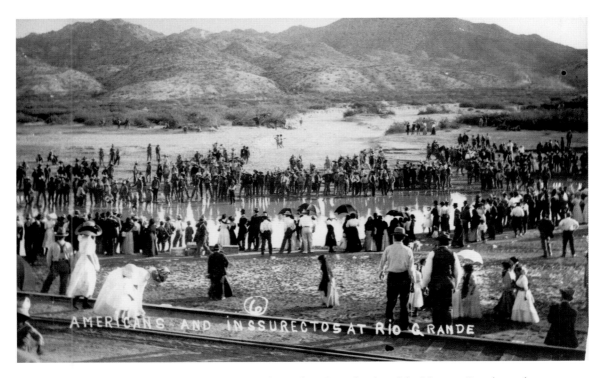

Unattributed, *Americans and Insurrectos at Rio Grande*, no date. Some battles of the Mexican Revolution between *federales* and *insurrectos* played out so near the border that crowds of tourists turned out to watch in El Paso, on the American side of the river. Americans strolled along the northern bank in tranquil moments or watched the heat of the battle from the relative safety of building tops, while bullets flew across the river. Courtesy of the El Paso Public Library, Southwest Collection (Postcard 9192 PC125).

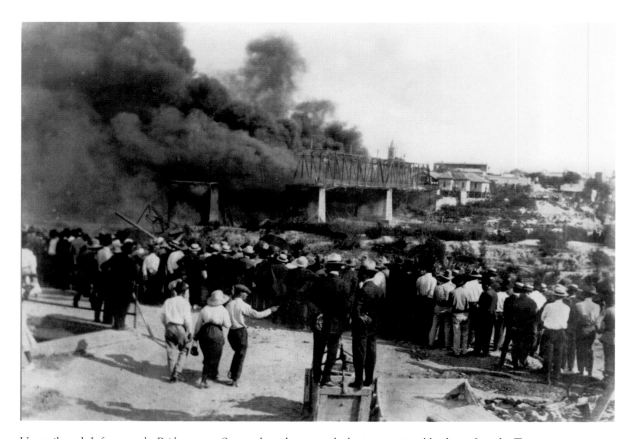

Unattributed, *Inferno on the Bridge*, 1920. Stunned residents watch the international bridge at Laredo, Texas, go up in flames in 1920. This site was an ancient crossing point for *indigenes* in small canoes, followed by ferries, then the first international bridge across the river to Nuevo Laredo, Mexico. A flood took out a replacement bridge in 1954. From the collection of James C. Kirkpatrick, courtesy of James E. Kirkpatrick, restoration work by Irene Vidaurri Zubeck.

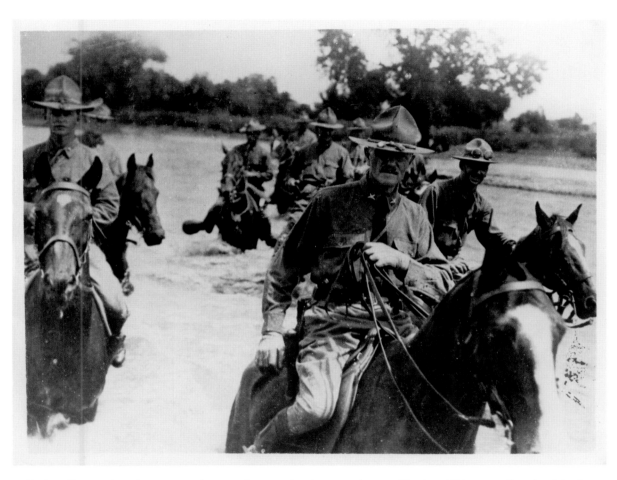

Wilfred Dudley Smithers, [Brig. Gen. John J. Pershing Leading his Troops], 1917. Woodrow Wilson sent Brigadier John J. "Blackjack" Pershing and five thousand US troops across the river on a 1916 expedition to punish Pancho Villa for his raid on Columbus, New Mexico. Here, Pershing and then lieutenant general George Patton ride back from Mexico in 1917, having neither captured Villa nor stopped cross-border raids. Photography Collection, Harry Ransom Center, the University of Texas at Austin.

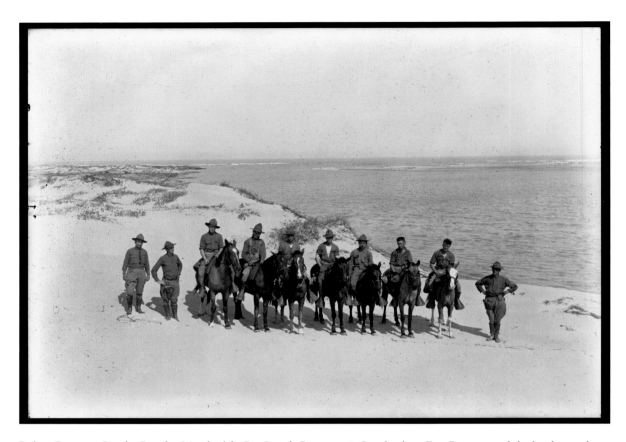

Robert Runyon, *Cavalry Patrol at Mouth of the Rio Grande River*, 1916. Cavalry from Fort Brown guard the border on the sandy banks of the Río Grande. Fort Brown was established just upriver from the mouth of the river in 1846, at the start of the struggle between Mexico and the United States over Texas territory. It was briefly an important Confederate port, shipping cotton from the South to European markets and military supplies to the Army of the South. Robert Runyon Photograph Collection, RUN00615, the Dolph Briscoe Center for American History, the University of Texas at Austin.

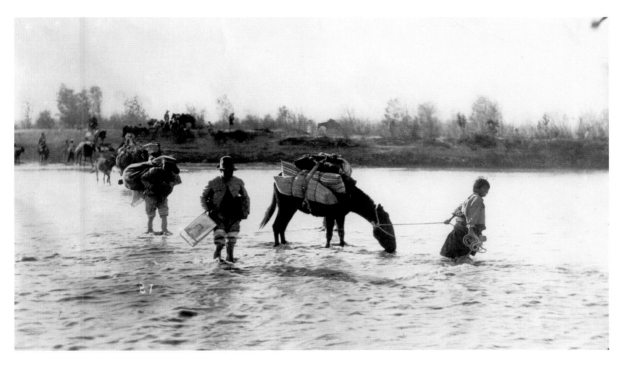

Otis A. Aultman, *Refugees in Mid-Stream*, ca. 1910–1920. The Mexican side of the Río Grande was a dangerous place for civilians during the conflicts of the Mexican Revolution, and many sought refuge across the river in the United States. Most refugees were farmworkers, but professionals also crossed the border seeking to establish lives in Texas. Courtesy of the El Paso Public Library, Southwest Collection (A5650).

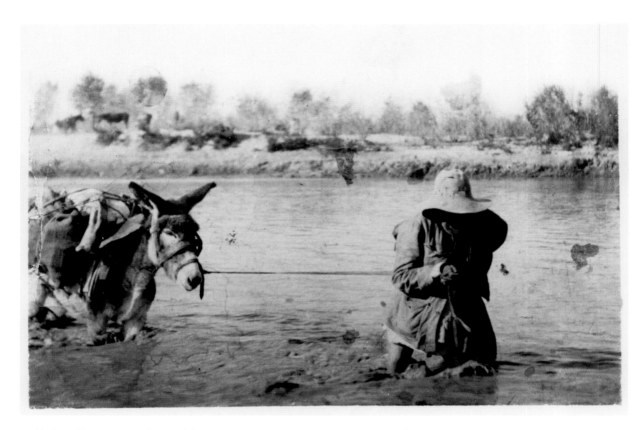

Wilfred Dudley Smithers, [Very Old Mexican Refugee Crossing the Rio Grande], 1914. A lone refugee from conflict on the Mexican side of the river pulls a burro loaded with his possessions. Mexican farmhands were welcomed into the United States during World War I labor shortages. Photography Collection, Harry Ransom Center, the University of Texas at Austin.

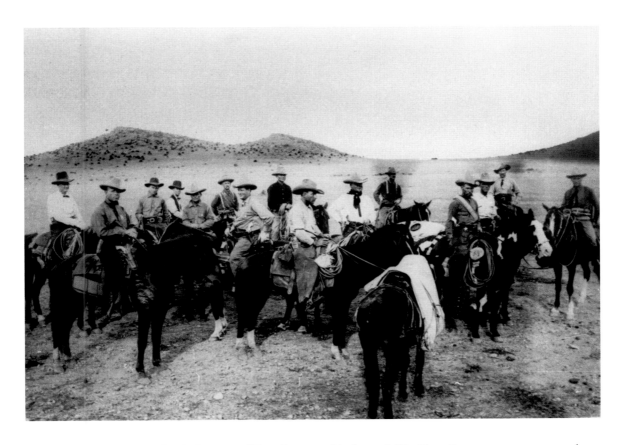

Unattributed, *Captain Jerry Grey's Company of Texas Rangers at Marfa*, 1918. The Texas Rangers were an agency of the law formed to protect the infant Republic of Texas, after it declared independence from Mexico and before it was granted US statehood in 1846. Texas Rangers were infamous lawmen in a rough country. The agency had a complex and sometimes ruthless history of keeping law and order along the border. Archives of the Big Bend, Bryan Wildenthal Memorial Library, Sul Ross State University, Alpine, Texas.

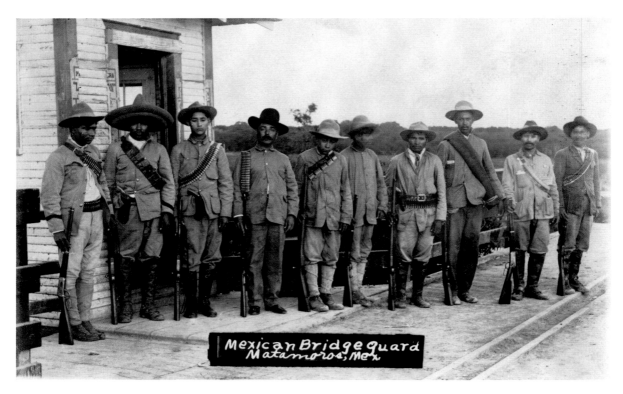

Unattributed, [Mexican Bridge Guards], ca. 1915. Mexican bridge guards protect the border at the international bridge between Brownsville, Texas, and Matamoros, Mexico, during the tumultuous years of the Mexican Revolution. Wittemann Collection, LC-USZ62-41534, Library of Congress.

Big Bend

Jan Reid

The earliest map of the Río Grande, drawn by Enrico Martínez in 1601, uses two names—Río del Norte, or River of the North, which flows through Colorado and New Mexico, and Río Bravo, the Wild River, south of the confluence with Mexico's Río Conchos (named for its shells). The River of the North all but disappears into the sands of the harsh desert it encounters below El Paso, but it then receives a generous infusion of water from the Río Conchos, born in Mexico's Sierra Madre Occidental. The combined flows surge southward, only to find their course nearly blocked by a collision of mountain ranges, creating the river's Big Bend.

Confronted with massifs that rise mile after mile, the Río Grande cuts its own remarkable slice through that great rind of stone. From the confluence with the Río Conchos, or la Junta de los Ríos, at Presidio, Texas, and Ojinaga, Chihuahua, the river drills and winds southeast through the most majestic of its canyons. Then the unyielding bulwark of Mexico's Sierra del Carmen range forces it to wrench northeast, then southeast once more, toward the Río Grande's lower canyons and the refreshing inflow of the New Mexico–born Pecos River and spring-fed Devil's River. These dramatic redirections of flow are why a vast curve of landscape in Texas is called Big Bend.

In its southern reaches, the Río Grande is an intermittent desert stream.

Back in the 1850s, US Army colonel W. H. Emory undertook a two-year survey of the international border. His report included the observation that a herd of goats could be driven all the way north from Presidio to El Paso in the bone-dry Río Grande streambed. Today the scarcity of water can be attributed to the unquenchable thirst of the cities of El Paso and Juárez, global climate change, dams in New Mexico, and massive irrigation of fields of pecans, chiles, and onions. Legally, the water flows from the hands of lawyers, who divide the flow between nations and states in lengthy court battles over water rights.

Because the Río Conchos never runs dry, the early assumption was that it was the parent stream. Río Conchos tributaries stretch like tree roots into the western Sierras, the domain of the Tarahumara Indians. Tamed by several huge dams, the River of Shells still crashes down spectacular waterfalls and canyons. The Cañón del Peguis, between Chihuahua City and Ojinaga, is as awe-inspiring as any of Big Bend's chasms.

La Junta, the confluence of the two rivers, has a beguiling folk name— el Columpio del Diablo, "the Devil's Swing." The myth has it that Satan rode a giant ball from the Texas side of the river and left a scrape and dent in Mexico, visible only to people with certain powers.

There are tales of revolutionary general Pancho Villa buying guns and ammunition from American suppliers in Presidio, Texas. In 1914, Mexican federal forces camping in the shells of blasted houses at the confluence of the Río Conchos and Río Grande were practically starving. Where could they flee when the final onslaught of Villa's rebels came? With two hours to spare, American authorities granted them free passage across the river.

Big Bend's canyons were not fully explored or documented or its rapids run until the 1899 voyage of Robert T. Hill, an officer with the US Geological Survey. He set out to survey the river from Presidio with five companions in three sturdy boats. Shortly after their launch, Hill's crew heard a roaring noise. Within moments, they were fighting for their lives in rapids crashing over volcanic rock. On the second day, they encountered the chocolate-colored cliffs of the Bofecillos Mountains and entered Murderer's Canyon, named for a Mexican outlaw called Old White Lip. After Fresno Canyon, with 600-foot cliffs of bright red volcanic rock, they emerged into a gentle valley with cottonwood groves. Next came the pale limestone Santa Elena range and, in Hill's words, "almost in the twinkling of an eye . . . [we] passed out of the desert glare into the dark and silent

depths of its gigantic canyon walls, which rise vertically from the water's edge to a narrow ribbon of sky above" (Hill, "Running the Canons," 379). The cliffs there loom 1,750 feet straight up. Then came the aptly named Camp Misery, where Hill's party faced a terrible three-day portage over a rockslide with 200-foot-high boulder piles.

Mariscal Canyon finally made the bend north, and the voyagers floated past a Mexican village, San Vicente, built near the ruins of a Spanish fort. Another canyon run brought them to a larger village, Boquillas. Both hamlets are now across from Big Bend National Park. Americans in search of beer and tequila visited both until 9/11, when Homeland Security cracked down on contraband and ended the visits. A local ranger, Marco Paredes, claims, "That border has never been a hard, fast line. People do come across, and they're not going to stop. Contraband has always been a part of life on the border—whether it's cocaine or chickens or blue fountain pens. But people in San Vicente never wanted a tourist economy. They're just trying to hang on to a traditional way of life. To say people in these villages pose a security threat is just absurd" (Paredes, in Reid, *Rio Grande*, 133).

Robert T. Hill's crews rowed ten hours a day for over a month. They mapped and navigated more than 350 miles of river. They knew they were done when they saw the outskirts of Langtry, Texas, and were received by Judge Roy Bean himself, the self-styled "Law West of the Pecos."

Still today, river runners face rapids that are not for the fainthearted and pass through chasms with cliffs so sheer and close they almost cut off the sky. For seven days, they almost never see another human soul.

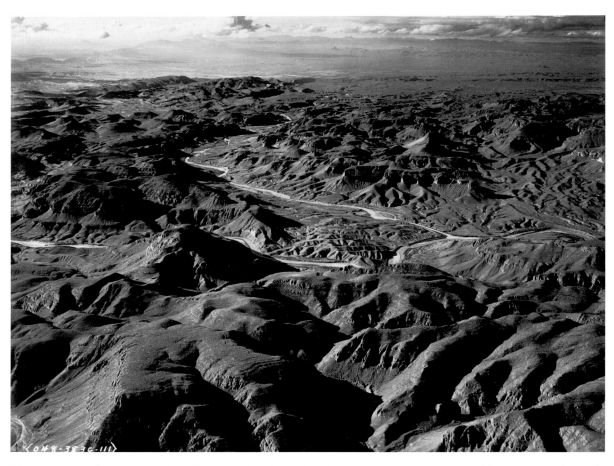

Thomas Verner Skaggs or J. Sterling Skaggs, *Bend in the Rio Grande*, 1937. In a panoramic view of the country to the north of Big Bend, the Río Grande is in the foreground. Across the landscape, left to right, are Dog Canyon, Santiago Peak, the Davis Mountains, Mount Ord, and the Glass Mountains. At the beginning of this great curve of the river, its largest tributary, the Río Conchos, enters from Mexico. Archives of the Big Bend, Bryan Wildenthal Memorial Library, Sul Ross State University, Alpine, Texas.

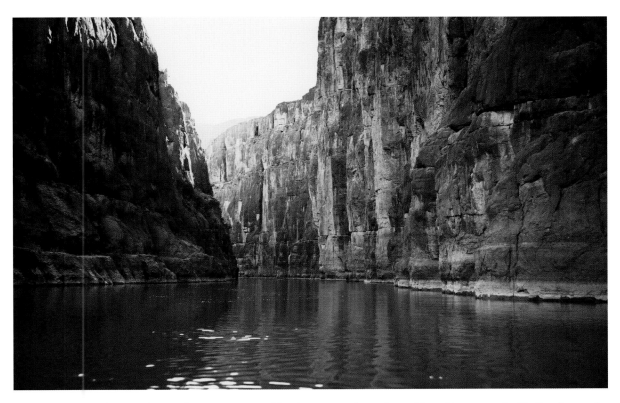

Henry B. DuPont, [Big Bend, Texas], ca. 1846–1847. The deep, magnificent Santa Elena Canyon in the Big Bend area of Texas was inaccessible for decades after the Río Grande Valley was settled. The river cut through limestone laid down by ancient seas to create steep cliffs in a narrow canyon. The daunting isolation of the canyon is said to have provided a hideout, Smuggler's Cave, for outlaws and cattle rustlers. Henry B. DuPont, [Big Bend, Texas], ca. 1846–1847, gelatin silver print, P1975.153.128_S, Amon Carter Museum of American Art, Fort Worth, Texas.

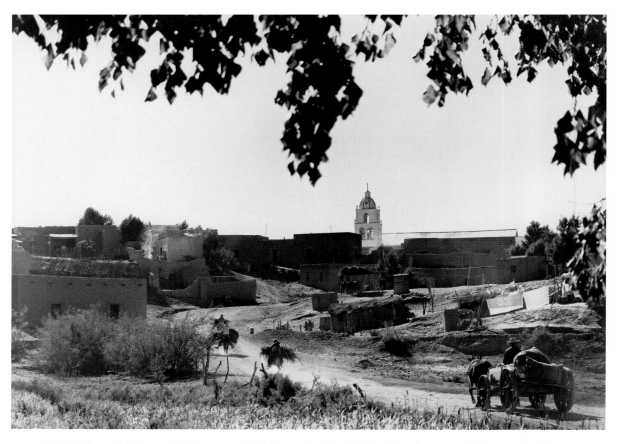

Laura Gilpin, *Ojinaga, Mexico*, 1946. Ojinaga, on the Mexican banks of the Río Grande, was settled just south of the confluence with the Río Conchos, the enormous Mexican tributary that replenishes the flow of the lower Río Grande. Graceful cottonwood trees, the icon of the bosques, or riverbank forests, frame the sleepy village. Ojinaga was famous for its unique norteño accordion music. Laura Gilpin, *Ojinaga, Mexico*, 1946, gelatin silver print, P1979.134.106, Amon Carter Museum of American Art, Fort Worth, Texas.

R. T. Hill, *Mr. Hill's Party Leaving the Canyons at Langtry*, 1899. As of the 1890s, the Big Bend area, isolated by its deep canyons, was still largely unmapped. R. T. Hill, *second from left*, a pioneering geologist in the border region, led the first expedition down the canyons of Big Bend, in October 1899. Hill and five others braved floods and rapids on a monthlong expedition into unknown territory, from Presidio to Langtry, Texas. R. T. Hill, courtesy of the US Geological Survey.

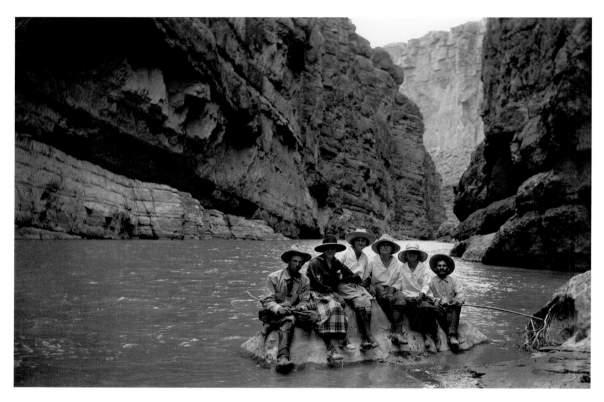

Thomas Verner Skaggs, *Young People on Outing, Santa Elena Canyon*, ca. 1915. This boulderful of picnickers were among the first of many to seek pleasure in the breathtaking scale of Santa Elena Canyon. The popularity and beauty of the landscape eventually inspired the establishment of Big Bend National Park. Archives of the Big Bend, Bryan Wildenthal Memorial Library, Sul Ross State University, Alpine, Texas.

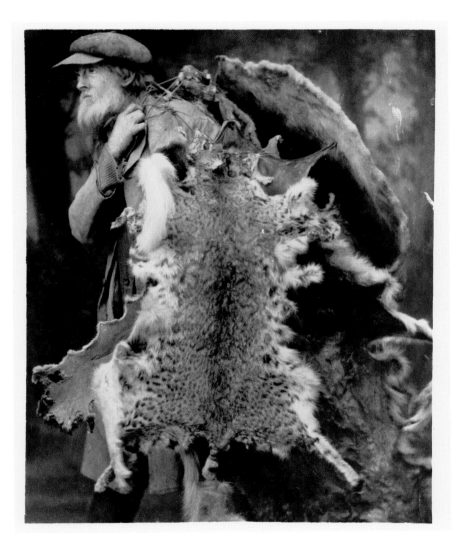

Wilfred Dudley, [The Most Noted Character along the Rio Grande], 1920. A notorious character who haunted the canyons of Big Bend, Jim McMahon started out as a Texas Ranger, guarding the surveyors who were establishing the International Boundary. Then, for years, he spent winters in the canyons trapping beavers and other furbearers and summers fishing for catfish and turtles. The story was that McMahon was uniquely safe from Native Americans, who feared his albino features. Photography Collection, Harry Ransom Center, the University of Texas at Austin.

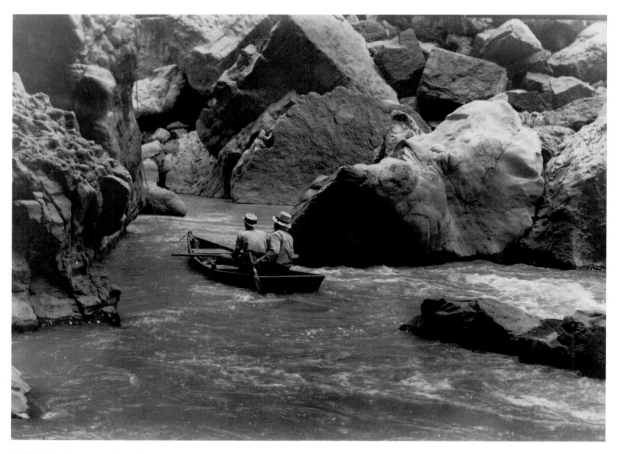

Wilfred Dudley Smithers, [Big Rocks and Rapids inside the Deep Santa Helena Canyon], 1937. In 1937, when few people had yet been in the canyons of Big Bend, these two men ventured their luck, heading into the dangerous rapids of the river in the thousand-foot-deep Santa Elena Canyon. Photography Collection, Harry Ransom Center, the University of Texas at Austin.

Wilfred Dudley Smithers, [Wrecked Wooden Boat], 1926. The river in Big Bend's canyons made for daunting rapids and smashed boats. The identity of the navigator of this boat found in Santa Elena Canyon is unknown, but that year alone, three men wrecked their boats, and one man drowned. Photography Collection, Harry Ransom Center, the University of Texas at Austin.

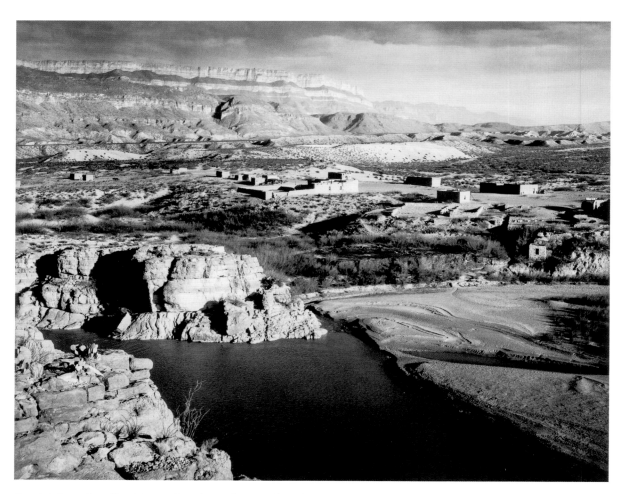

Ansel Adams, *Boquillas, Mexico, Dust Storm from North Bank of the Rio Grande, Big Bend National Park*, 1942. A dust storm on the horizon prepares to sweep down on the tiny Mexican village of Boquillas, framed by the parched Chihuahuan Desert of the Big Bend area. The fate of Boquillas, always a gritty, remote village, was tied to the nearby silver and lead mines. A classic boom-and-bust town, its population grew and diminished with the fortunes of speculators. *Boquillas, Mexico, Dust Storm from North Bank of the Rio Grande, Big Bend National Park*, 1942, photograph by Ansel Adams, © the Ansel Adams Publishing Rights Trust, gelatin silver print, P1975.118.8, Amon Carter Museum of American Art, Fort Worth, Texas.

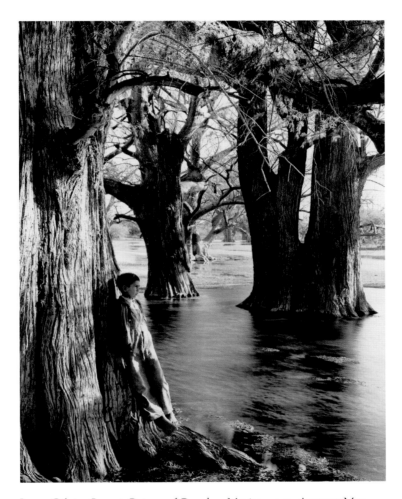

Laura Gilpin, *Swamp Cypress of Cerralvo, Mexico*, 1949. A young Mexican boy stands in a cypress swamp near Cerralvo, a village founded by Jose Luis de Carvajal y de la Cueva to press local Native Americans into labor in the silver and lead mines. Abundant springs create marshes and swamps that flow down to the Río Grande. The Río San Juan, Río Salado, and Río Conchos, other ample Mexican rivers, flow north into the Río Grande, known in Mexico as the Río Bravo. Laura Gilpin, *Swamp Cypress of Cerralvo, Mexico*, 1949, gelatin silver print, P1979.134.356, Amon Carter Museum of American Art, Fort Worth, Texas.

River's End

Dan Flores

The art historian Vincent Scully once proposed that the oldest representation of a landscape in the history of art is of a river coiling through a valley bordered on either side by mountain ranges. I like that. I have lived my whole life on rivers. The Red River of Louisiana is my placental river, nourishing three hundred years of my dad's family and my own youth, but it did not hold me. Later, I lived on the headwaters of the Brazos River in West Texas and, still later, on the Bitterroot River in the blue-green world of Montana. Now, and for well over a decade, my home river is the Río Grande, the subject and focus of the photos and essays here. I should be specific though. Actually, I live on a tributary of the Big River, on the south rim of the valley of the Río Galisteo, which lays down a swipe of watery sand south of Santa Fe, then runs along the famous escarpment called La Bajada, until it joins the River Grand near Santo Domingo Pueblo.

This sounds adventuresome and romantic until you consider that, with variations in places and names, every person in the United States lives this way. We are all residents of rivers, even when we're oblivious to the connections. As someone has said, or ought to have, it doesn't make any difference whether you believe in things like evolution or global climate change, to cite our political battle of the moment. They're still happening all around you, whether you acknowledge them or not. Rivers are like

that. The giant sprawl of Los Angeles has a river, although few of its residents pay the slightest heed. But the truth is that we are all river rats, and we should never get so wrapped around modern life that we lose sight of the fact. Rivers, like a beating heart when we pause to take our pulse, are one of our connections to the tangible, organic world. We've been living alongside them and off of them forever. We should pause every now and then to acknowledge the wonder of that.

I have been preparing to say—and who will dispute it, turning the pages of this book—that the Río Grande stands second only to the Colorado as the greatest river of the American Southwest. And in terms of continuous human history, the Southwest is the oldest place in the United States. That alone makes this an important volume. Lingering over these historic, sometimes-famous photos and in-this-moment words from deeply connected Río Grande residents is a visceral pathway to the river's nonchalant sense of timelessness. Paul Horgan's two-volume tribute *Great River*, a book published sixty years ago, can still do that too, but somehow photographs are even better. What a pity we have had the time machine—as Melissa Savage calls it—of photography available to us for a mere 175 years! On the other hand, at least we have had the photograph that long. Silver print images may not give us the whole visual story of this whole river's history through time and geography, but the images we have deliver many insistent moments, demanding that we pause and see truly.

Ten steps from where I am writing this, I can stand on my front porch and look out to the middle portion of this great river. Through wrinkled, tan hills and cinder cones speckled with green junipers like a pointillist painting, my eyes can follow the Galisteo River on its sun-drenched course westward into the Big River's rift valley, a setting eerily reminiscent of the true natal home of humanity in East Africa. Under the ethereal blue dome of New Mexico, a blue that will still be here after we are gone, this is a stunning place to be. And a river runs through all of it.

Dan
Flores

Unattributed, *Aerial Photo at the Mouth of the Rio Grande*, ca. 1938. The Río Grande wanders across a broad, flat delta littered with oxbow lakes, or resacas, on its meandering way to the Gulf of Mexico. Scattered orchards presage the transformation of the delta into a rich agricultural landscape of cotton, citrus, and sugar. Brownsville Historical Society, Texas.

Robert Runyon, *Fishing Group at the Mouth of the Rio Grande*, ca. 1920. Fishermen proudly display their catch, a kind of ray called a sawfish, on a pier in Port Isabel, Texas, just north of the river's mouth. Despite frequent battering by hurricanes from the Gulf of Mexico, the town had long been a cool seaside refuge for inland ranchers and a commercial and sport fishery. Robert Runyon Photograph Collection, RUN08898, the Dolph Briscoe Center for American History, the University of Texas at Austin.